W9-CFO-506

Richard Haas

THE CITY IS MY CANVAS

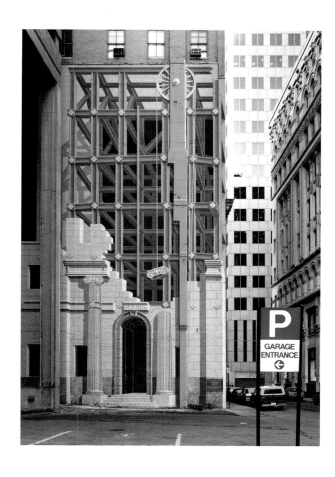

Richard Haas

THE CITY IS MY CANVAS

With an introduction
by Richard Haas

and an essay
by Beth Dunlop

Prestel Munich · London · New York

For my wife, Katherine, my son, Gregory, and John Szoke

I would like to thank all the artists who have worked with me in my studio
as well as the individuals who have represented me and administered my
projects. I would especially like to thank John Szoke, who introduced
Jürgen Tesch, of Prestel Verlag, to me and my work. Richard Haas

Front cover:
Homage to Cincinnatus, Brotherhood Building, Kroger Company, Cincinnati, Ohio, 1983
Executed by Evergreene Painting Studios, New York

Half title page:
31 Milk Street, Boston, Massachusetts, 1986
Executed by American Illusion, New York

Frontispiece:
The Boston Architectural Center, Boston, Massachusetts, 1975–77
Executed by Seaboard Outdoor Advertising, New York

Back cover:
101 Merrimac Street, Boston, Massachusetts, 1990
Executed by American Illusion, New York

Library of Congress Card Number: 2001086183
Cataloging data is available

© Prestel Verlag, Munich · London · New York, 2001
All illustrations, unless otherwise noted, are courtesy of the artist, by prior
arrangement between him and the respective copyright holders where applicable.
All sources are listed in the photo credits at the back of the book.

Prestel Verlag
Mandlstrasse 26 · 80802 Munich
Tel. +49 (089) 381-7090, Fax +49 (089) 381-70935

4 Bloomsbury Place · London WC1A 2QA
Tel. +44 (20) 7323-5004, Fax +44 (20) 7636-8004

175 Fifth Avenue · New York, NY 10010
Tel. +1 (212) 995-2720, Fax +1 (212) 995-2733

Prestel books are available worldwide.
Please contact your nearest bookseller or one
of the above Prestel offices for details concerning
your local distributor.

www.prestel.com

Copyedited by Michele Schons, Munich
Designed by Cilly Klotz, Munich

Lithography by Repro Ludwig, Zell
Printed by Peradruck, Gräfelfing
Bound by Sigloch, Blaufelden

Printed in Germany on acid-free paper

ISBN 3-7913-2505-1

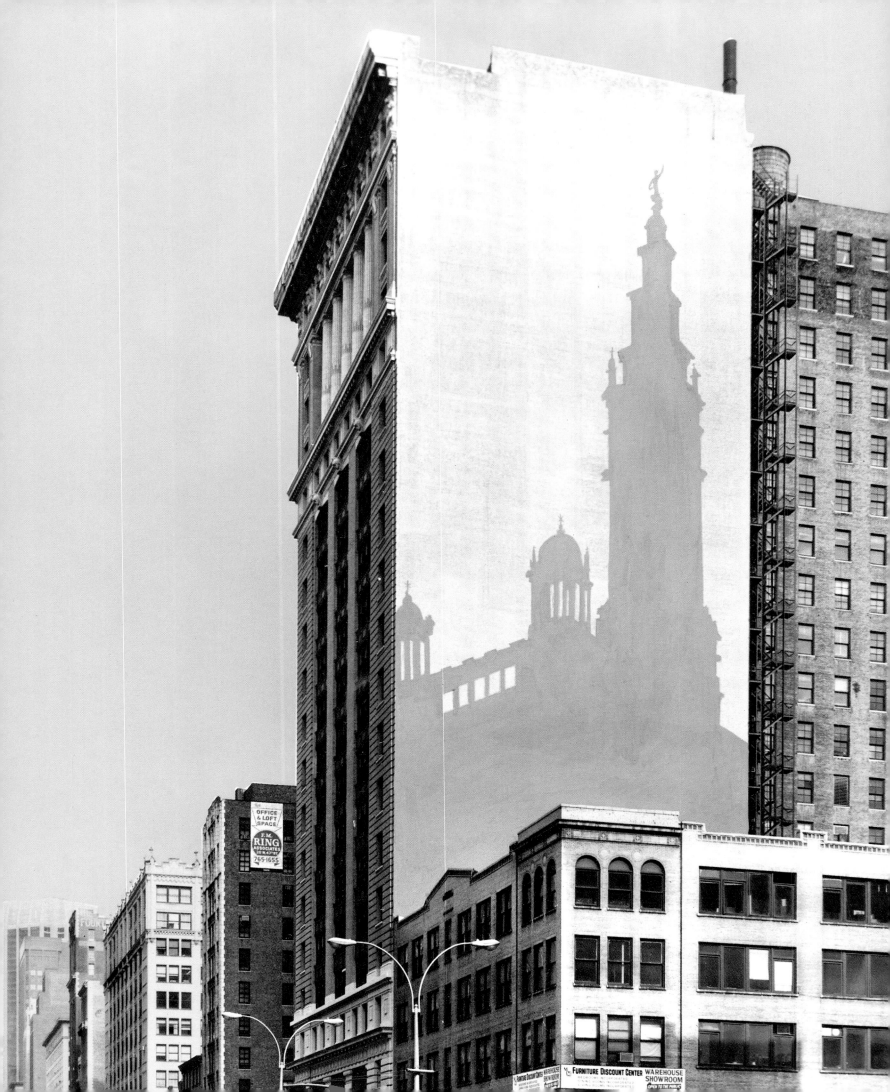

The City Is My Canvas

by Richard Haas

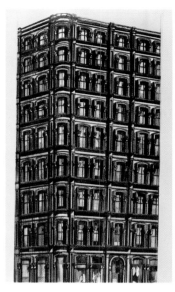

91–97 Nassau Street, Lower Manhattan,
New York City, drypoint etching, an
example of one of the more than one
hundred graphic works the artist has made

Fresco, ca. 60–50 B.C., Villa of the Mysteries, Pompeii

Opposite: An unrealized "shadow" proposal
depicting a shadow of the original Madison Square
Garden, ca. 1975

The several dozen murals that I have now completed on building facades, most of which are in American cities, began in a simple and didactic manner — as an outgrowth of the many drypoint etchings of architectural facades that I have made. After several years of working on small, three-dimensional, dioramic boxes, initially of artists in their studios and eventually of the streets and interior spaces of my SoHo neighborhood, I conceived a number of designs for shadows, which were to represent and commemorate the buildings that had once stood near the sites in question. My first executed work, located on the corner of Prince and Greene Streets, New York City, was a straightforward extension of the cast-iron Prince Street main facade, wrapped around the five-story party wall of the building facing Greene Street. This was the result not only of my graphic work but also of several other interests of mine.

First, I had just completed three trips to Europe, where I had seen the remnants of the long tradition of facade painting in northern Italy, southern Germany, Switzerland, and other Central European countries. Although I was familiar with these from photographs and old postcards in my parents' travel folios, I had never seen them first hand.

Quadratura painting, illusionistic decoration painted on walls and/or ceilings that appears to be an extension of the actual architecture, was, as excavations reveal, originally a Roman tradition. After having experienced a revival in the Renaissance, it reached its height of expression in the Baroque period, several hundred years later. Although most of the outdoor works have perished, thousands of examples of interior *trompe l'œil* painting can still be admired in countless churches and palaces throughout Europe.

My interest in the American city was another motivating factor. The regular grid pattern that characterizes the American city was in the process of being decimated in the 1950s and 1960s in order to make room for freeways and parking lots, leaving countless gaping wounds and exposed walls. These became opportunities for artists, and many art movements sprang up at this time in New York City, Los Angeles, Chicago, and elsewhere. These movements varied widely in style and intent. The LA Art Squad, working in greater Los Angeles, was

7

The artist's living room/studio, at 81 Greene Street, New York City, was his first interior transformation, 1974–75.

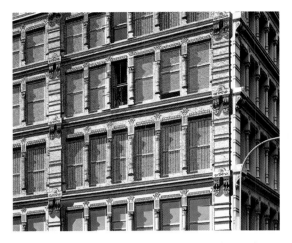

The mural at 112 Prince Street, New York City, was the artist's first exterior project, 1975. It carries the style of the building's facade around the entire building onto a blank party wall.

dominated by surrealists and hyper-realists, while in New York the hard-edged abstractionists founded Citywalls, sponsored by Doris Freedman. Moreover, in several cities indigenous artist groups were influenced by the ethnic and social issues taken up in the murals of Diego Rivera, José Clemente Orozco, and other Mexican artists.

That was the scene when I designed my first mural, which was executed by Citywalls from 1974–75. I had, however, begun employing *trompe l'œil* techniques even earlier, when altering and embellishing interiors, such as my own studio in SoHo and the nearby Nelson loft on Canal Street. This marked the beginning of a series of commissions that I continue to receive today to execute interior murals and room alterations. Most of these are in large public spaces rather than in private homes, and some compete in size with the outdoor works.

The art historian E. H. Gombrich, who has written numerous books and articles on illusion in art, maintains that our perception has always run ahead of our cognition, causing us to classify what we see (i.e., door, chair, window, tree, etc.), and that our brain takes the cues offered in a picture and transforms them such that it is difficult to distinguish between illusion and reality. A gap in a circle, for example, will automatically be filled in visually by our brain. We are constantly tricking ourselves optically. That great Western invention, or lie, called perspective is a sensibility so compelling that, once acquired, it is hard to shed. It's an age-old game that leads one to conclude that some-

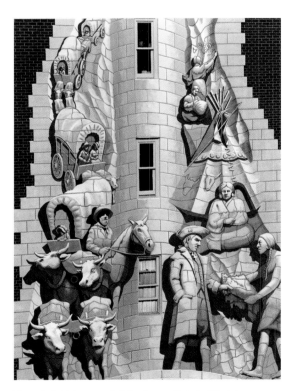

The artist's history mural at the Oregon Historical Society, Portland, 1989

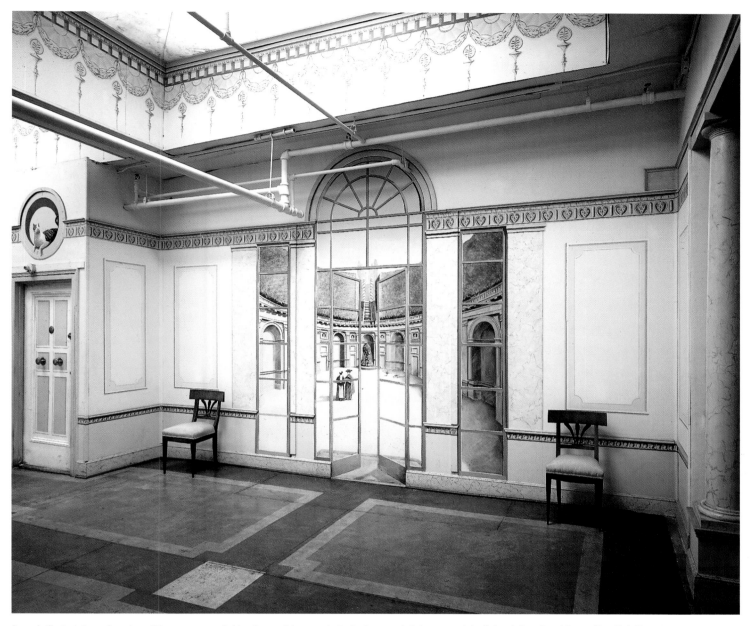

An early illusionistic work: a view of the passageway linking the receiving area to the bedroom and dining room of the Nelson loft on Canal Street, New York City, 1976

thing exists when it does not. When our interest is piqued because the trick has been revealed, a new set of perceptions takes over.

My use of *trompe l'œil,* however, was never merely an end in itself, but a means to grab the viewer's attention. It was my hope that, once thus engaged, the viewer might seek other layers of meaning and be able to read the larger story told by the artwork. By marrying the painted architecture as closely as possible to the existing architecture, I endeavored to make the encounter with the painting as "plausible" as possible, to make one feel that it belongs where it is, that it was always part of the natural cityscape. I believe this is what makes the most

successful pieces. It is also why I insist on maintaining a certain degree of artistic control over the projects.

Since the dawning of architecture, buildings have been fitted with sculptures and friezes that convey their own narrative. The archaeological sites of Ur, Karnak, Persopolis, Angkor Wat, Borubudor and Uxmal are magnificent examples of such sculptural architecture. This tradition has also made itself felt in European and American architecture, examples of which range from the temples of Greece and Rome to the cathedrals of Europe and even to the banks, merchant palaces, and government buildings of modern-day America. In many of my alterations of buildings I have undertaken to carry on this tradition in order to tell their history. Thus the story of Oregon can be seen on the Oregon Historical Society building and the history of Yonkers on a number of buildings in that town. I have also noticed that one can have a positive effect on a community as a whole by placing a series of facade murals in a dense urban space. One such project was carried out in Huntsville, Texas, over a ten-year period. It started in 1990 with a combination of city funds and grants. Overseen from the outset by Linda Pease, a local government official, this project is still underway. In three successive efforts, fifteen buildings and a ruin were treated with a combination of painted and built finishes, which slowly helped bring that small urban center back to life.

The world is constantly changing and the needs of the city change with it. What the cities of America needed twenty-five years ago is certainly not what they need today. Our sensibilities and tastes also change. It is interesting, however, to see how much remains the same in spite of the improved veneer of many city centers. What is even more noticeable is that the blight, visual and otherwise, has simply moved outside the older city centers to the inner suburbs. In my view this is where the greatest challenges lie today. Even if blank urban walls at key locations around cities are now seen primarily as opportunities for computer-generated advertisements, large fringe areas of the urban American landscape remain in dire need of refinement, softening, and improvement. This is an even more challenging aesthetic battle zone for our immediate future.

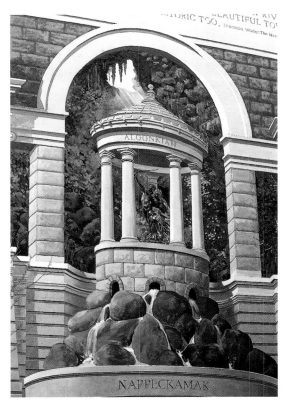

View of the Nympheum in *Homage to Yonkers,* Gateway to the Waterfront, Yonkers, New York, 1997

This fake "ruin" in Huntsville, Texas, 1999, is part of the city's overall plan to transform and revitalize its downtown.

More Than Meets the Eye

by Beth Dunlop

Guarino Guarini, dome of San Lorenzo, 1668–87, Turin, Italy

The painted building has a long and noble history—from ancient Greece and Rome to the Renaissance and beyond. Indeed, ever since prehistoric cave dwellers drew pictographs on stone, the wall has been a source of stories and ideas conveyed by means of art. The illusionistic paintings of Richard Haas give the mural new dimensions. He is an artist, yes, but he also functions as critic, historian, archaeologist, architect, detective, dreamer. His work is ambitious in scope and unlimited in its power of observation. To see the city as Haas paints it is to see it as it has been, as it ought to be, as it could be.

Haas makes connections that cities themselves lack, filling in great glaring gaps left in the wake of urban renewal. In a career that spans nearly four decades, Haas has transformed otherwise bland curtain-wall buildings into gloriously detailed, if indisputably faux, period works. Some of them seem so real that it is almost impossible to see them for what they are: two-dimensional paintings; others leap far into the fantastic, inviting our imaginations to take wing. His painted facades—and, to a lesser extent, his interiors—expand our awareness of our surroundings, our consciousness of what encapsulates the notion of *civitas.*

Some of Haas' works lead us into the past, while simultaneously catapulting us into a visionary future. They start with what is known, with what can be seen, and venture far beyond this. In essence, fantasy and reality become one in Haas' painted walls, so much so that it is difficult to know where the actual ends and illusion begins.

Though his work possesses a remarkably real quality, Haas resists being labeled a *trompe l'œil* artist, rejecting the term as "too stereotyped and trivialized as well as misunderstood." Nonetheless, he clearly embraces the Renaissance tradition of painting that turns simple spaces into complex constructions, as seen in Guarino Guarini's dome in the Chapel of the Holy Shroud in Turin. Haas himself acknowledges having "steadily admired" a host of Italian artists, ranging from Giulio Romano, Raphael, Michelangelo, Andrea Mantegna, and Piero della Francesca to Gianlorenzo Bernini, Giovanni Piranesi, and even exponents of the German Rococo.

Though this artistic legacy is virtually omnipresent in Haas' work, it is not the driving force. He does not merely imitate; he melds

Paolo Veronese, Villa Barbaro, ca. 1560–61, Maser, Italy, detail of fresco depicting young girl in doorway

real history with inventions of the past, architecture with architecture-related art. Haas works according to what he calls "self-inflicted principles," namely that the painting must be plausible, believable, and connected to the site in scale.

He is very much an artist of his own time, relying on the Modernist notion of collage to bring together images, ideas, and allusions from a variety of sources, both real and mythical. "I feel comfortable in appropriating elements and devices from the past, but I do not feel that there is an historic imperative in my work," says Haas. "In many ways collage is the invention of the 20th century, and it allows us to combine elements, past and present, in unusual and disjointed ways. When I seek to weld these elements together, I try to do it in a plausible way." Haas describes himself as "an addict of urbanism and cities in general," which is to say that he can see beauty in cacophony. "What excites me most is when I find a place that is a multi-layered series of piles that only time and history can cause."

He grew up at a time when the mandates of modern architecture were accepted unquestioningly. He is not solely a critic of modern architecture, of the contemporary city; his work is more sophisticated, more layered than that. The critical eye is there, but it is what he calls a "hidden agenda." Still, even in his most complex and subtle pieces—the Boston Architectural Center (1975–77), for example, where he created a fantastic cross section of a domed Neoclassical space on the wall of a brutalist concrete building—the message is there for all to see. As palpable as the work is, it is not merely nostalgic. It is both sweet and tough. Haas' love of architectural richness, of the potential of the environment of any building to be enhanced, is clearly conveyed. Mildly, he terms his work "simple, logical," and, indeed, both those traits are revealed in Haas' murals and painted buildings; however, much more is at work.

In some cases, it seems that his work actually fulfills an unfulfilled destiny. The artist turned a Montgomery Ward store in Fullerton, California (1985), for example, into an Art Deco fantasy, and one would be hard-pressed to say that it was not predestined as such. The drive-through First Bank and Trust Company of Corning, New York (1982), a sad addition to a formidable stone Neo-Romanesque structure, was transformed from a pathetic into an architecturally compelling building. In Huntsville, Texas (1990–2000), the artist restored an urban character to a row of long-neglected downtown buildings.

Before-and-after photographs are instructive, even illuminating. To see the Tarrant County Courthouse (1988) before Haas adapt-

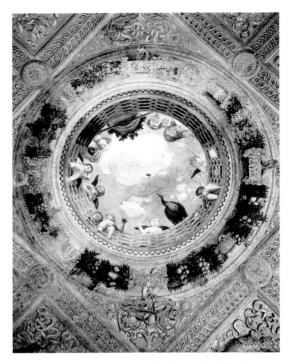

Andrea Mantegna, ceiling fresco in the Camera degli Sposi, 1664–74, Palazzo Ducale, Mantova, Italy

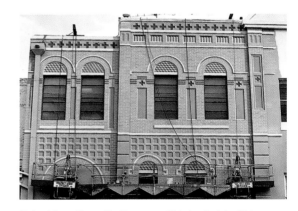

Richard Haas, Huntsville, Texas, ca. 1992, detail of the Gibbs Building being painted

12

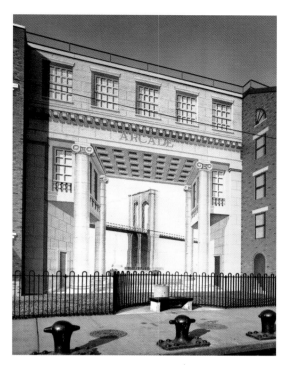

Richard Haas, Peck Slip Arcade, 1978, view "through" painted arcade toward Brooklyn Bridge

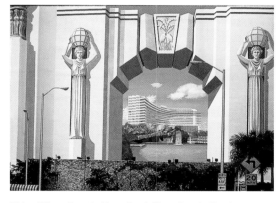

Richard Haas, Fontainebleau Hotel, Miami Beach, Florida, 1985–86, view "through" painted archway toward Hilton Hotel

ed it is to see the low point of American architecture turned by Haas into a piece of Fort Worth's history, providing what he calls "contextual unity." The blank south wall of the Fontainebleau Hotel in Miami Beach (1985–86) long stood as a reminder of urban insensitivity. Painted by Haas as a magical view through the wall to the hotel beyond, it is a veritable wonder. In it, office towers, warehouses, "left-over" party walls—victims of neglect, demolition, or unmitigated architectural dullness—were transfigured by Haas' hand.

Some works offer the beholder fulfillment, a kind of finality. In his painted extension of the cast-iron facade of the building at 112 Prince Street, New York (1975), or in his work on the Strand, Galveston, Texas (1976), Haas completes the incomplete, giving the eye what it expects to see. Elsewhere, at Peck Slip Arcade (1978) on South Street Seaport, in the shadow of the Brooklyn Bridge, or at the Fontainebleau Hotel in Miami Beach, he depicts the impossible—a view through the impenetrable. The idea is at once witty and metaphysical—chimerical views through buildings, views into inaccessible worlds that actually exist, yet not quite as they are painted.

Architecture is capable of telling stories, to which Haas' murals attest. Many of them—such as the Oregon Historical Society in Portland, Oregon (1989), for example—tell the story directly, in some instances embracing the tradition of the great Mexican muralists and their immediate successors, the many artists who painted during the Depression under the auspices of the WPA.

In Yonkers, New York, the artist's murals from 1997, depicting a dream sequence of archways, pay tribute to both the present and the past. The ensemble includes the Nympheum, inspiration for which Haas drew from the Untermeyer Gardens in that city as well as from the gardens at Kykuit on the Hudson River, a residence of the Rockefellers. There is also a "Dutch" mural—acknowledging the city's earliest settlers—which takes its architecture from the city hall, and an "English" ensemble including St. John's Church, a block away, as it looked in 1780. A final painted archway depicts Yonkers in the 1890s. This project was particularly imbued with meaning for Haas, as he, his sculptor-wife, Katherine, and their son reside in Yonkers.

The son of a German-immigrant butcher and a third-generation German mother, Richard Haas was born in 1936 in Spring Green, Wisconsin, a small, traditional town of that state, with a main street and a movie house. As a child, Haas was fascinated not only by architecture but also by representations of architecture—wood carvings, doll houses, dioramas. Avidly, he sought images of buildings, cross

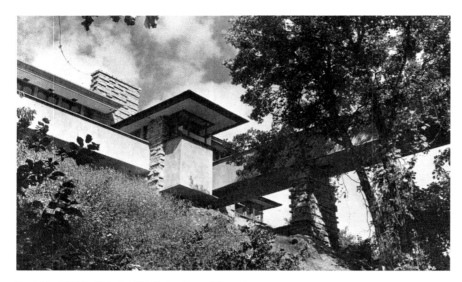

Frank Lloyd Wright, Taliesin, 1911, Spring Green, Wisconsin

sections, maps, photographs, postcards. In turn, Haas painted what he discovered in pictures or clay models of buildings.

Spring Green was also the town where Frank Lloyd Wright decided to build Taliesin (1911), his house and study center. For Haas, Wright loomed larger than life. "My first memory of Mr. Wright was when I was about six and he and his entourage stepped out of his Indian red Lincoln to go to the movies in Spring Green." Throughout high school, Haas studied Wright intensely; he read books by and about Wright and made numerous drawings of his buildings. By then his family had moved to Milwaukee, but, in the summer of his nineteenth year, Haas persuaded his stonemason uncle, who worked for the architect, to hire him. He went to Taliesin that and the following summer, with Wright's approval, and spent much time looking at drawings and copies of drawings.

After the summer of 1955, Haas returned to the University of Wisconsin's Milwaukee campus, where he was a student, and began to study painting in earnest. From there, he frequently visited the Art Institute of Chicago, where he was able to see exhibitions of the work of numerous major nineteenth- and twentieth-century painters. This is also when he began painting on a larger scale.

Over the next half-decade, Haas explored many art forms and styles. "I tried to assimilate and imitate those avant-garde works seen mostly in museums and magazines." In the summer of 1962, he accompanied his University of Minnesota graduate school instructor Peter Busa to Provincetown, Massachusetts, where he made the acquaintance of such artists as Robert Motherwell, Helen Frankenthaler,

14

Richard Haas, dioramic box, 1971, 12x10 in. The box contains a view of Greene Street in SoHo, New York City, as seen from the artist's studio.

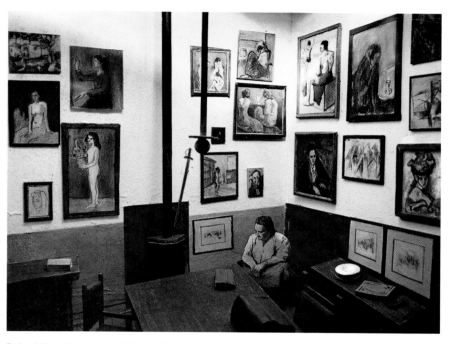

Richard Haas, dioramic box, 1968, 9x12 in. The scene depicts Gertrude Stein in her dining room in Paris, surrounded by her art collection, ca. 1906.

Kenneth Noland, David Smith, Hans Hofmann, Red Grooms, Mark Rothko, and others. Although this experience instilled in him the desire to move east, it would be years before he actually did so. In 1964, after attending graduate school in Minnesota, Haas accepted a teaching position at Michigan State University in East Lansing, where he remained entrenched in what was then the "avant-garde," though privately the "closet realist" had begun working on small dioramas, the shadow-box precursors of his large-scale public works.

The dioramas offered three-dimensional views into artists' studios, including those of Augusto Giacometti, Pablo Picasso, Henri Matisse, Jackson Pollock, and, of course, his childhood idol, Frank Lloyd Wright; other dioramas represented interiors seen in the paintings of Jan Vermeer and Jan van Eyck. These works were explorations of perspective, of dimension, of a kind of miniaturized peep-show illusion. Haas created them in secret, for he did not regard them as "serious avant-garde stuff." Yet, the dioramas began to spell out Haas' future: they dealt with space and time, architecture and art, memory and reality. Shortly thereafter, in 1968, Haas moved to New York and began ten years of commuting to Bennington College in Bennington, Vermont, where he taught printmaking. He settled first on the Bowery, but soon moved to SoHo, to a loft at Wooster and Broome Streets. His "boxes" began to reflect his own neighborhood of cast-iron buildings, one of warehouses and workers, not yet gentrified and transformed,

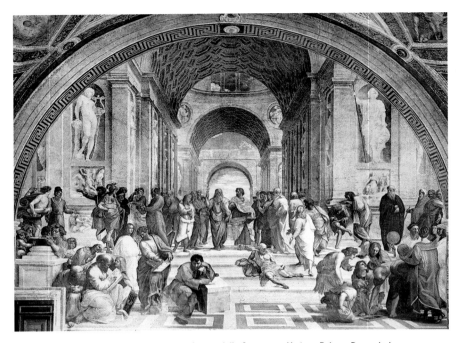

Raphael, *School of Athens,* fresco, 1509–11, Stanza della Segnatura, Vatican Palace, Rome, Italy

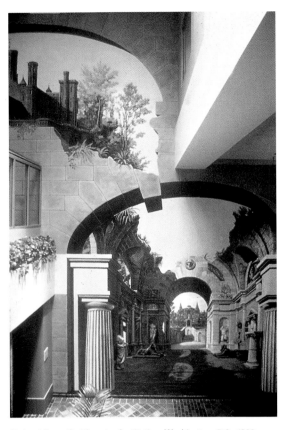

Richard Haas, Smithsonian Institution, Washington, D.C., 1986, detail of mural in the lower lobby of the Quadrangle Museum complex depicting ancient Roman ruins

not yet at the point at which, as Robert A. M. Stern once remarked of SoHo, "success proved to be, at least in the eyes of most of its pioneers, its undoing."

New York enabled Haas to follow his heart and mind; soon he was making etchings and drypoints of buildings, then watercolors, and subsequently pencil drawings. The latter were done on layers of paper with Plexiglas inserted between them, thus giving the works both depth and perspective. In this period, too, Haas began to travel widely. On various trips to Europe, he visited the southern Germany that he had previously known only through the photos in his parents' honeymoon album. Here, he discovered examples of painted buildings, such as the illusionistic works of the German Rococo. He also went to Italy, where he encountered entire painted villages in coastal Liguria and saw the frescoes of Paolo Veronese, Giambattista Tiepolo, and Baldassare Peruzzi. Donato Bramante's San Satiro in Milan and Masaccio's *Holy Trinity* in the church of Santa Maria Novella in Florence made indelible impressions on him, as did Gianlorenzo Bernini's works in the cardinal's palace in Rome, Michelangelo's ceiling paintings in the Sistine Chapel, and Raphael's papal apartments. Haas' interest broadened from individual buildings to the dynamics of the city at large, its smooth rhythms and cacophonies, its connections and contrasts; the "patterns and repetitions in the compositions of buildings on the street" fascinated him. The city was becoming his canvas.

Etienne-Louis Boullée, *Proposal for a Monument to Newton*, 1784

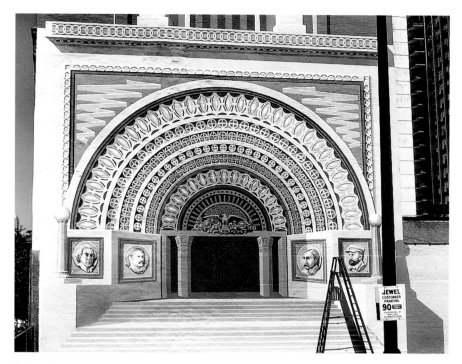

Richard Haas, *Homage to the Chicago School*, 1980, 1211 North Lasalle Street, Chicago, Illinois, detail of entrance arch inspired by Louis Sullivan's Transportation Building at the World's Fair, Chicago, 1893

But it was a changing city. In the 1960s, America experienced an unprecedented building boom in which new construction was undertaken with little regard—in fact with total disregard—for historic buildings or the urban fabric. Haas saw in these buildings, which stood alone like survivors, a pervasive sadness, to be sure, but also a certain triumph; on their own, the buildings became more, rather than less, "precarious, but often more beautiful, more human."

There were also big, blank party walls left behind, walls that seemed to cry out for intervention. In 1974, Haas persuaded the late Doris Freedman, the former director of an organization called Citywalls, to let him extend the facade of the building at 112 Prince Street in New York. The project was executed, as all others have been since, by sign painters working from maquettes scaled at somewhere between one inch to a foot, or one-half inch to a foot, depending on the size of the project. "What often happens, in our older cities especially," explains Haas, "is that the larger, newer, flatter curtain-walled towers form a backdrop to the older, smaller, and more delicate and detailed buildings of earlier generations and actually make them better."

His work on Prince Street, New York, in Galveston, Texas, and even his *Homage to the Chicago School* (1980) at 1211 North LaSalle Street in Chicago are all odes to the architecture that has filled and informed his life. A personal quality, a sense of reverence and homage,

raises these works from the mundane to an almost spiritual level. The memories that inform such works are long-lingering ones: Haas' *Black Hawk* (1992) in Rock Island, Illinois, features a mammoth painted "relief" of the Indian chief Black Hawk. Haas grew up in Black Hawk country, where he lived with the legends and, as a child, reenacted the famous Battle of Wisconsin.

Artistic passions have fueled other works, as well. At the Smithsonian, in 1986, Haas turned an underground passage into a passage through time, modeling its ruinous "excavation" on an eighteenth-century painting of ancient Rome by Giovanni Panini. Moreover, one of the artist's earliest works dealing with art and architecture is the wall showing a fantastic view of a domed structure at the Boston Architectural Center, a mural for a 1960s "brutalist" raw-concrete building. For this work, which he regards as a *tour de force*, Haas drew on the many Prix de Rome drawings he had studied over the years and saw it as a way to pay tribute to such eclectic, visionary eighteenth-century architects as Etienne-Louis Boullée and Claude Nicholas Ledoux. In some ways, it recalls a dreamscape; yet, like all Haas' works, it has a concreteness, a sense of context, that makes it seem real. Another work, at 31 Milk Street in Boston (1986), depicts a formidable Neoclassical facade being erected over a steel frame; it is at once fanciful and wistful, an elegy to architecture, but without sentimentalism or rancor. That, too, is true of his *Homage to the Chicago School,* where Haas was able to fill three walls of a previously undistinguished skyscraper with an assemblage of elements from celebrated buildings—Louis Sullivan's arched entrance to the 1893 Chicago World's Fair Transportation Building and a giant oculus window from Sullivan's 1914 Merchants' Bank in Grinnell, Iowa. Bas-relief likenesses of four Chicago School architects are included—Sullivan, Daniel Burnham, John Wellborn Root, and Haas' beloved Wright. On one face, Adolf Loos' rejected entry to the Chicago Tribune tower competition is depicted.

"I'm not interested in restoring things exactly as they were (this is seldom an option anyway) as the walls I'm given are more often than not left over blanks in an architectural program," says Haas. "I like to take existing conditions and build on them and this often leads to having to invent a style as a solution (i.e., the Chicago School mural or Edison Brothers building in St. Louis [1984]). The Renaissance was really a reinvention of the Classical past based on imagined fantasies of what that past was about. Our own young and aging cities can benefit from some reinvention as well."

Projects | Buildings and Interiors

Buildings

1 The Oregon Historical Society
Portland, Oregon

2 Gateway to the Waterfront
Yonkers, New York

3 City of Huntsville, Texas

4 Edison Brothers Stores, Inc.
St. Louis, Missouri

5 The Boston Architectural Center
Boston, Massachusetts

6 Chestnut Place
2300 Chestnut Street, Philadelphia,
Pennsylvania

7 *Homage to Chisholm Trail*
Sundance Square, Fort Worth, Texas

8 Crossroads Building
1465 Broadway at 42nd Street, New York City,
New York

9 Fontainebleau Hotel
Miami Beach, Florida

10 Fulton Theater (now Byham Theater)
Pittsburgh, Pennsylvania

11 *Homage to Cincinnatus,*
Brotherhood Building, Kroger Company,
Cincinnati, Ohio

12 31 Milk Street
Boston, Massachusetts

13 Tarrant County Courthouse
Fort Worth, Texas

14 The Bakery Center
South Miami, Florida

15 Centre Theater
Milwaukee, Wisconsin

16 Zwingerstrasse, near Isar Tor
Munich, Germany

17 *Homage to the Chicago School*
1211 North LaSalle Street, Chicago, Illinois

18 The Olin Terrace
Madison, Wisconsin

19 112 Prince Street
New York City, New York

20 P.S.E. & G. Electric Substation
New Brunswick, New Jersey

21 Peck Slip Arcade
South Street Seaport, New York City, New York

22 Thunderbird Fire Safety Equipment Corporation
Phoenix, Arizona

23 The First Bank and Trust Company of Corning
Corning, New York

24 Montgomery Ward Department Store
Fullerton, California

Interiors

25 Meredith Communications Headquarters
Des Moines, Iowa

26 101 Merrimac Street
Boston, Massachusetts

27 Federal Building and U.S. Courthouse
Kansas City, Kansas

28 Sky Lobby, Home Savings of America Tower
Los Angeles, California

29 Western Savings and Loan Association
Corporate Headquarters
Phoenix, Arizona

30 Landmark Square
Long Beach, California

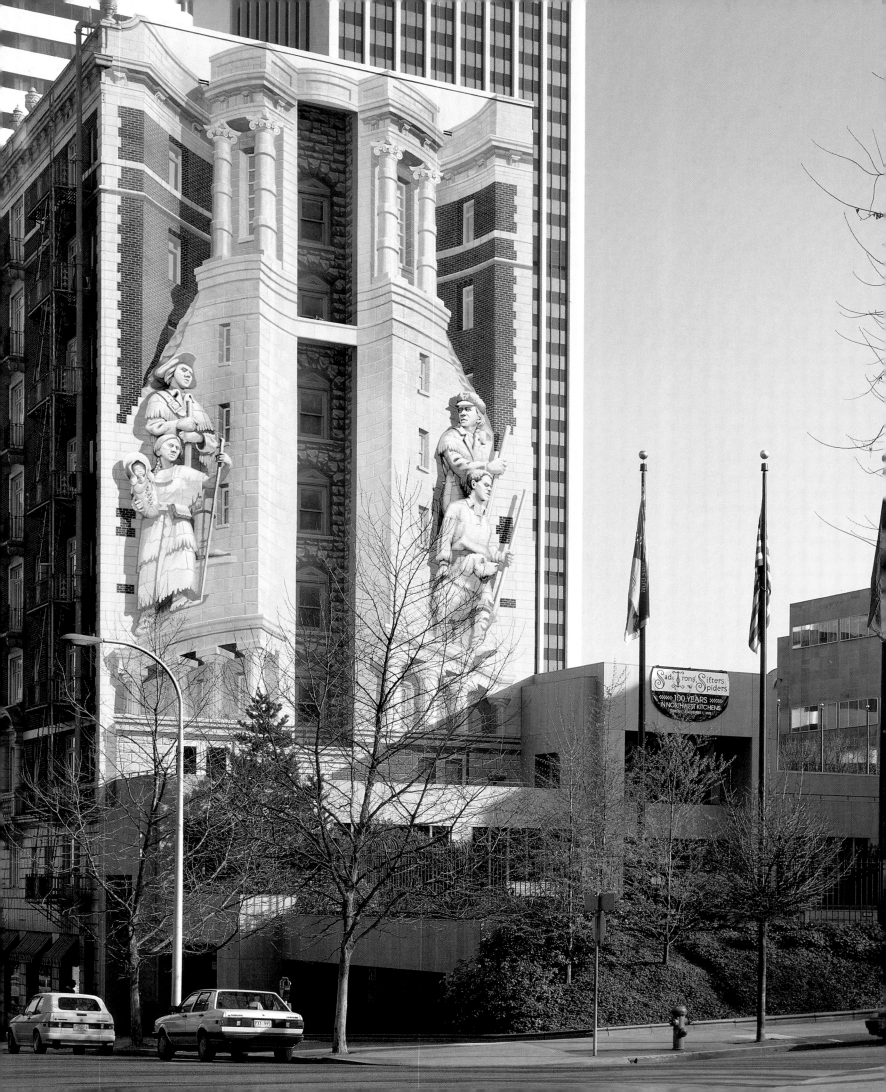

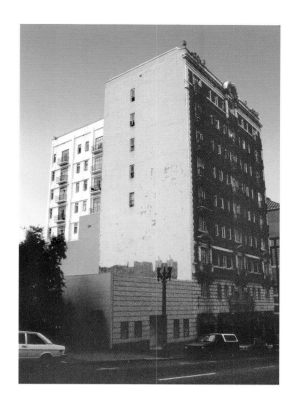

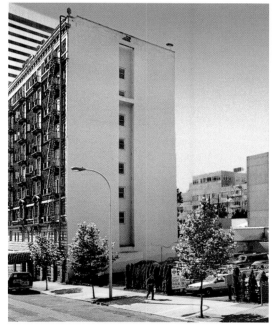

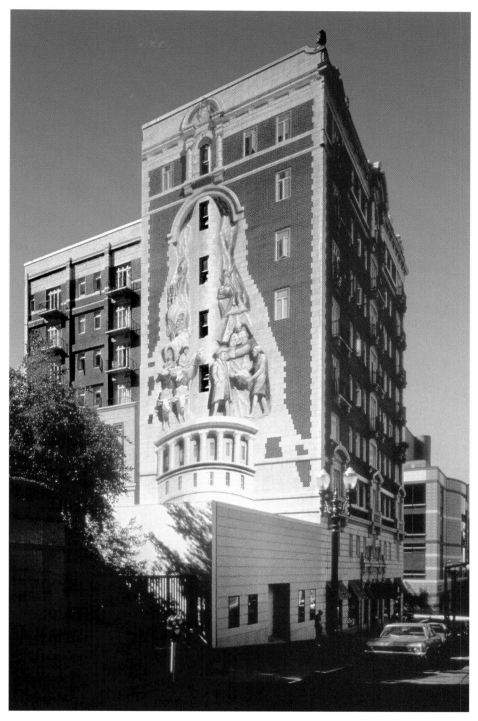

1 The Oregon Historical Society, Portland, Oregon, 1989
Keim silicate paint, 14,000 square feet
Commissioned by the Oregon Historical Society
Architect: Zimmer Gunsel Frasca Partnership
Executed by American Illusion, New York

The west face of this multi-part mural, painted on four sides of a six-sided
building, depicts four, thirty-feet-high participants of the Lewis
and Clark Expedition of 1804–05. The south face bears a *trompe l'œil*
frieze of the Oregon Trail and the John Jacob Astor fur trade.

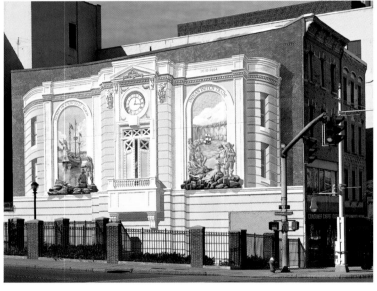

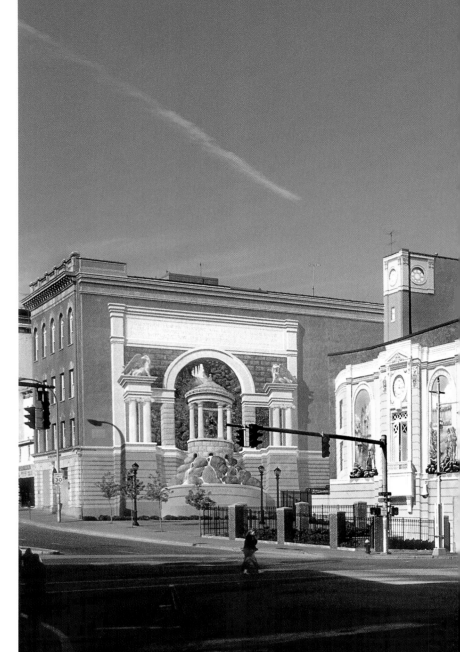

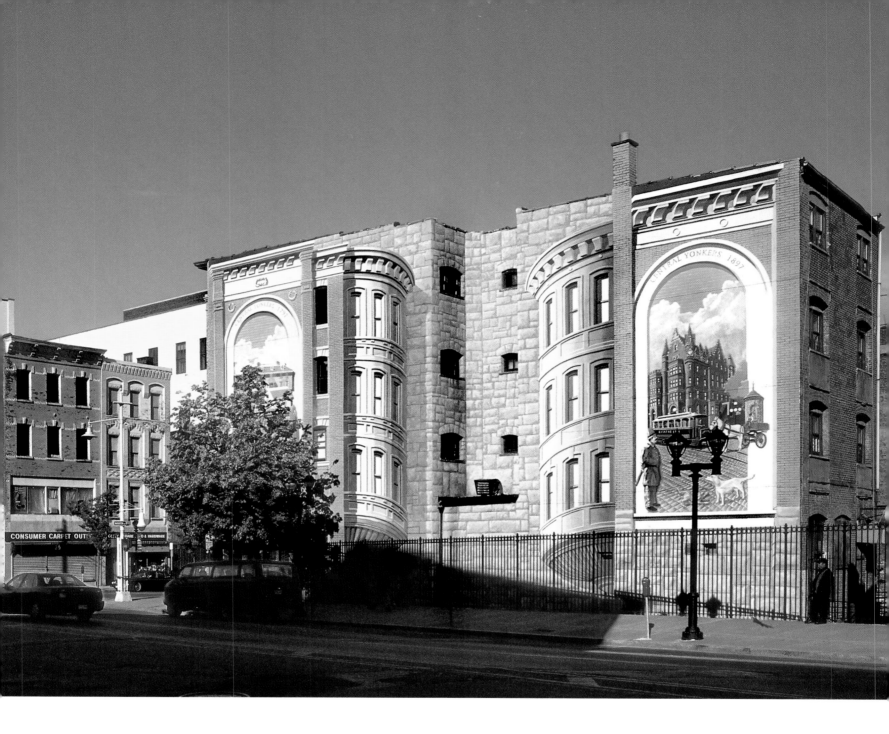

2 Gateway to the Waterfront, Yonkers, New York, 1997
Keim silicate paint on cement, 14,000 square feet
Commissioned by the City of Yonkers, Office of Downtown Waterfront Development
Executed by Evergreene Painting Studios, New York

These three murals, painted on three buildings in downtown Yonkers, depict figures from,
and episodes in, the history of Yonkers: Native Americans, Dutch settlers,
an eighteenth-century English village, and late nineteenth-century industrialism.

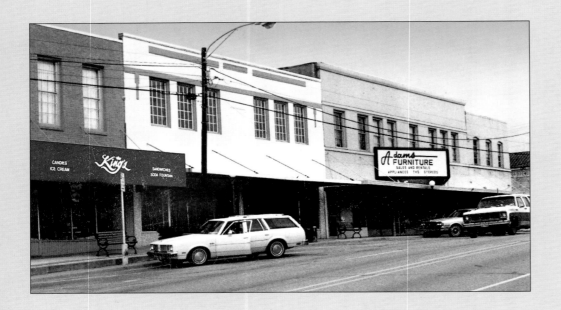

3 City of Huntsville, Texas, 1990–2000
Keim silicate paint, murals range in size from 400 to 3,500 square feet
Commissioned by the City of Huntsville with grants from the Meadows Foundation,
the National Endowment for the Arts, and the State of Texas
Executed by American Illusion, New York, and Thomas Street Studios,
Providence, Rhode Island

This project consists of thirteen buildings that have been painted on,
or improved upon through restoration, over a ten-year period.
The artist, in collaboration with architect Kim Williams of Austin, Texas,
and under the direction of Linda Pease of the City of Huntsville, has created
a faux ruin and restored and embellished two theater facades, a county courthouse,
a prison museum, and multiple store fronts.

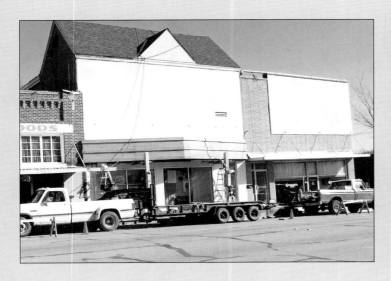

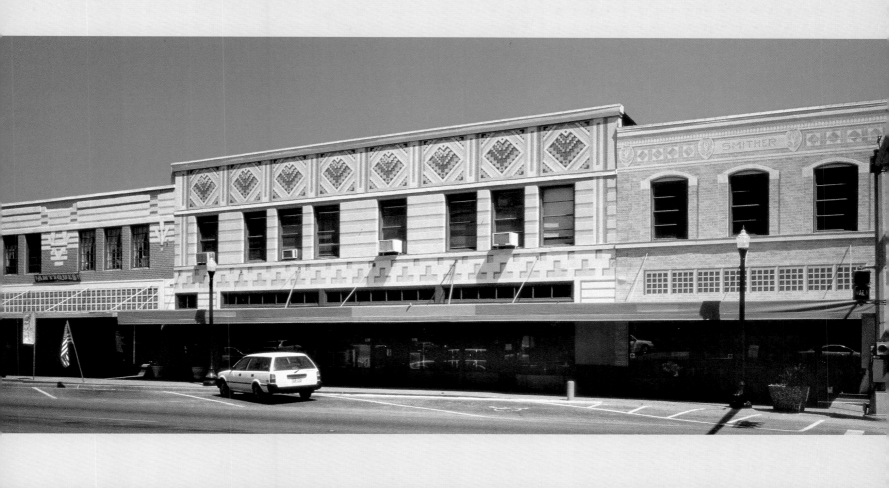

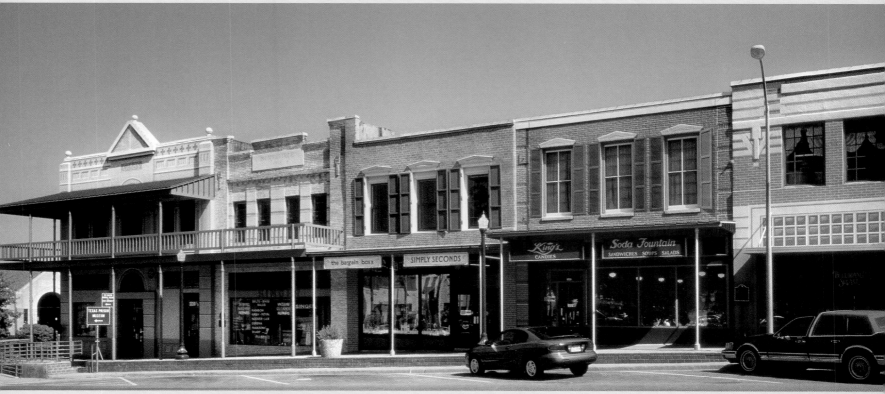

 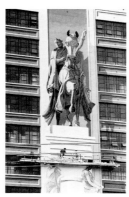

 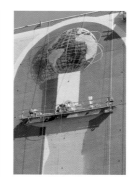

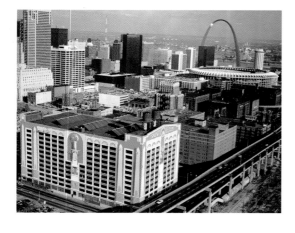

4 Edison Brothers Stores, Inc., St. Louis, Missouri, 1984
Keim silicate paint, 110,000 square feet
Commissioned by Edison Brothers, Inc., St. Louis
Executed by Evergreene Painting Studios, New York

This is a three-sided mural with eight obelisks at its corners,
a painted sculpture of Peace on the west facade,
and a painted equestrian statue of St. Louis on the south facade.

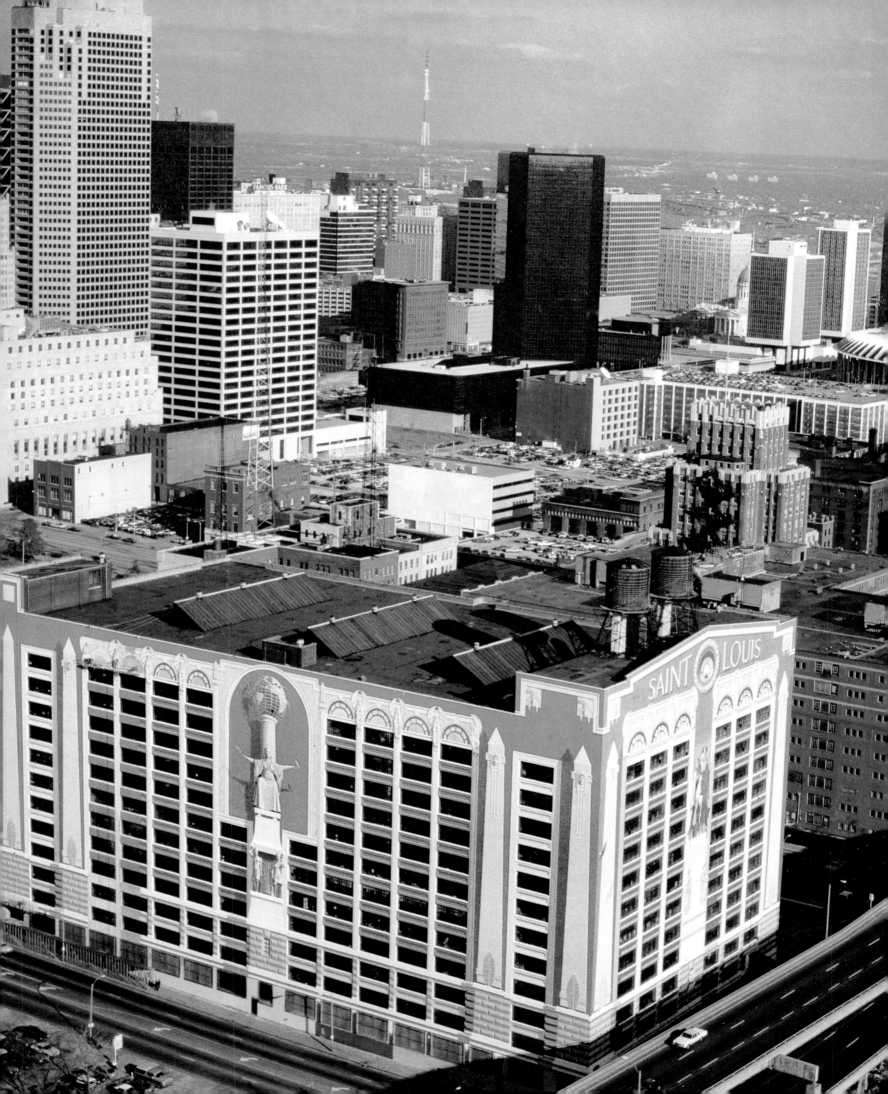

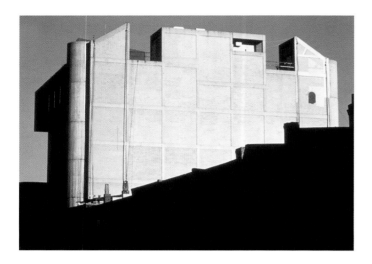

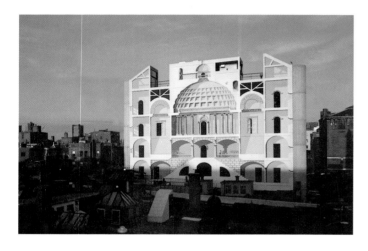

5 The Boston Architectural Center, Boston, Massachusetts, 1975–77
Oil paint, 6,800 square feet
Commissioned by the Boston Architectural Center with private grant assistance
Supervised by Citywalls, Inc., New York
Executed by Seaboard Outdoor Advertising, New York

Commissioned by the director of the Boston Architectural Center,
Peter Blake, this mural was the first to be "carved" into a wall in order
to reveal imaginary interiors. It was intended to simulate an
eighteenth-century architectural drawing.

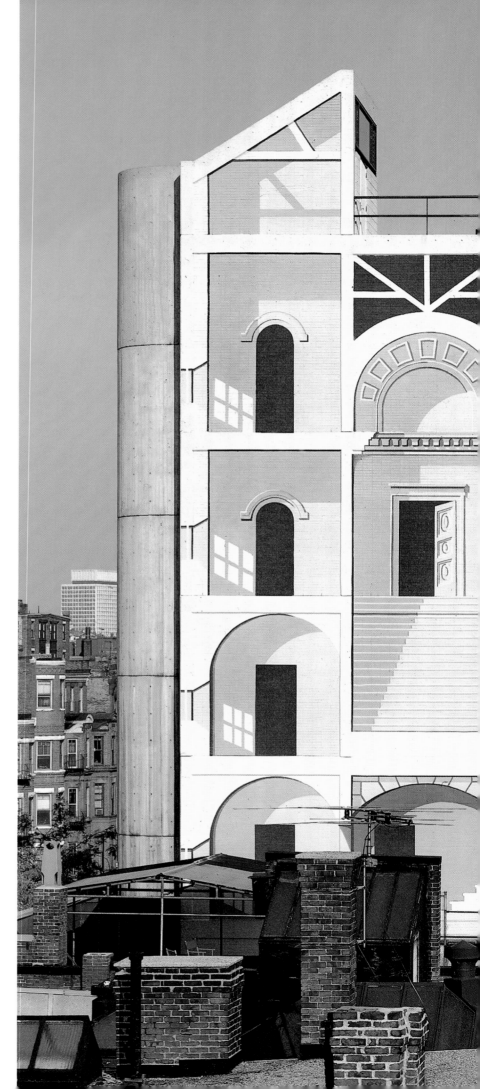

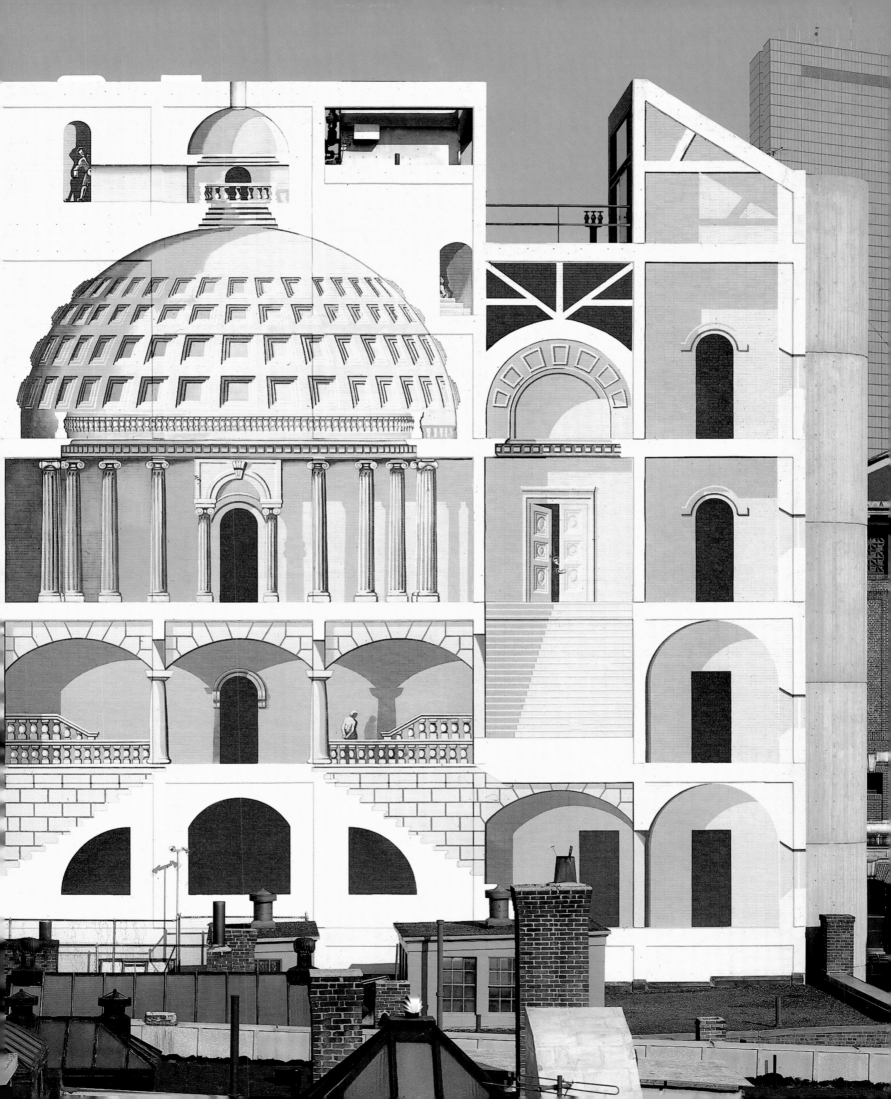

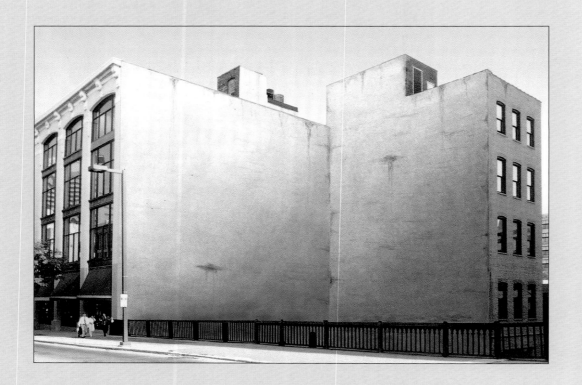

6　Chestnut Place, 2300 Chestnut Street, Philadelphia, Pennsylvania, 1983
Keim silicate paint, 15,000 square feet
Privately commissioned
Executed by Evergreene Painting Studios, New York

The five-floor corner office building was transformed into a labyrinth of arched
openings that contain a "figure" of William Penn, painted to scale after
his portrait at the city hall, and a view of a scull rower, appropriated from
Thomas Eakins' painting *Max Schmitt in a Single Scull*.

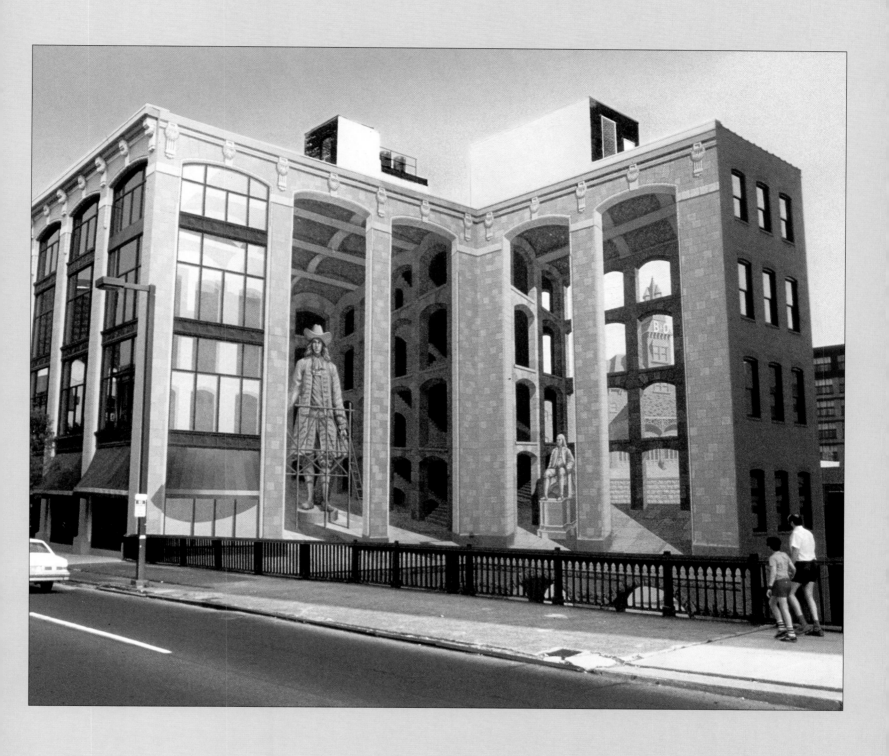

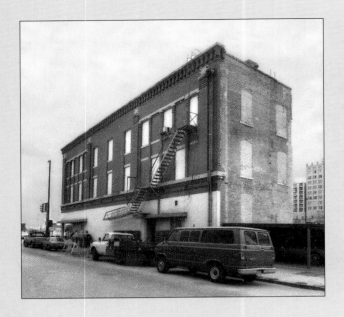 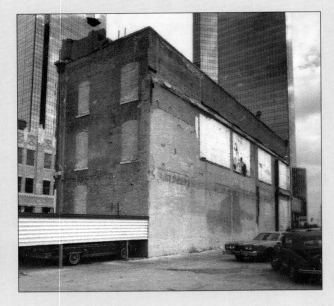

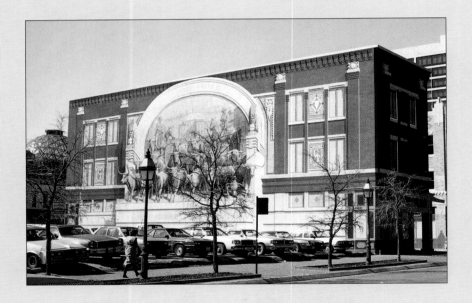

7 *Homage to Chisholm Trail,* Sundance Square, Fort Worth, Texas, 1985
Keim silicate paint on cement, 4,500 square feet
Commissioned by Sundance Square Development Corporation
Executed by Jonathan Williams, Los Angeles, California

Here the artist created a faux sculptural relief depicting an 1860s cattle drive through
downtown Fort Worth, when the Chisholm trail traversed this site.

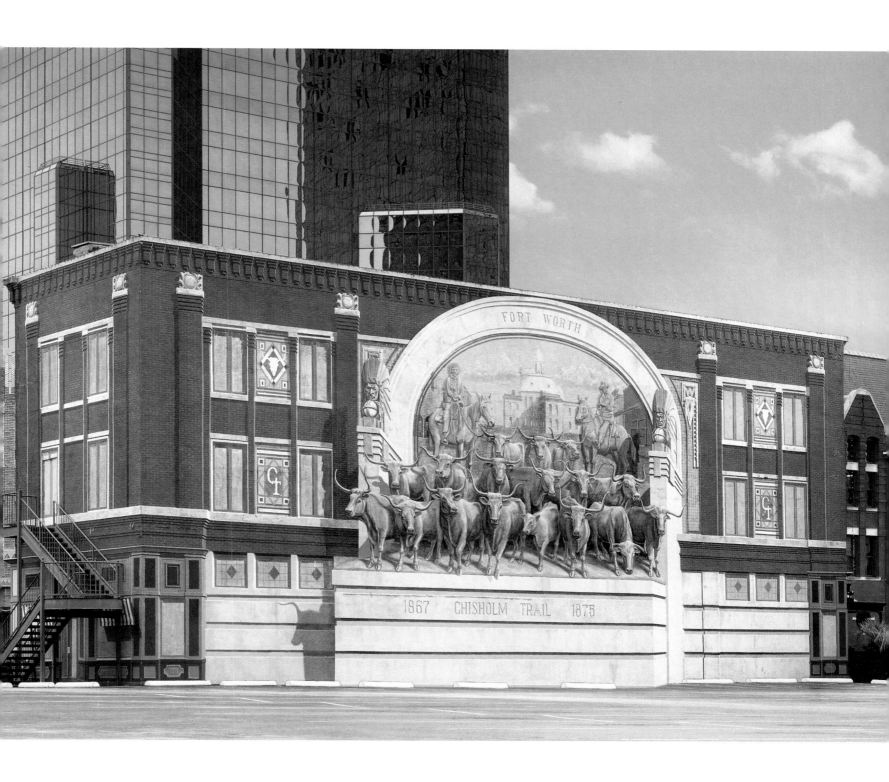

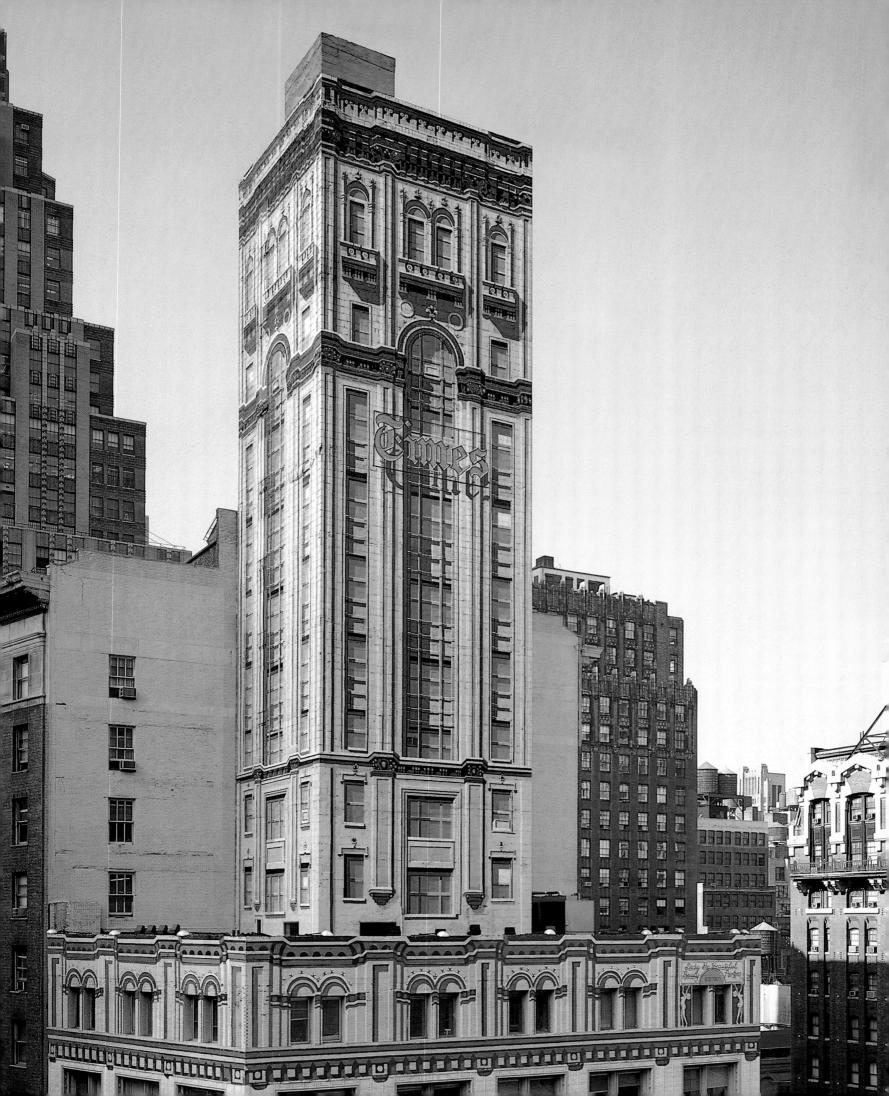

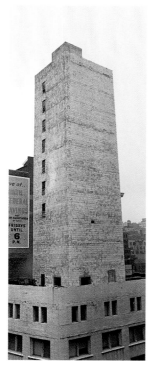
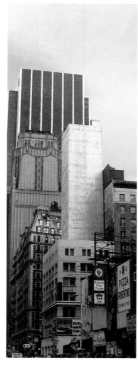
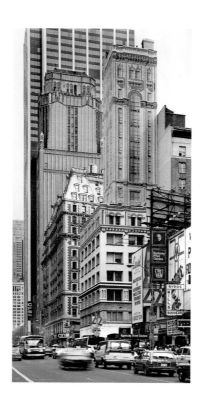
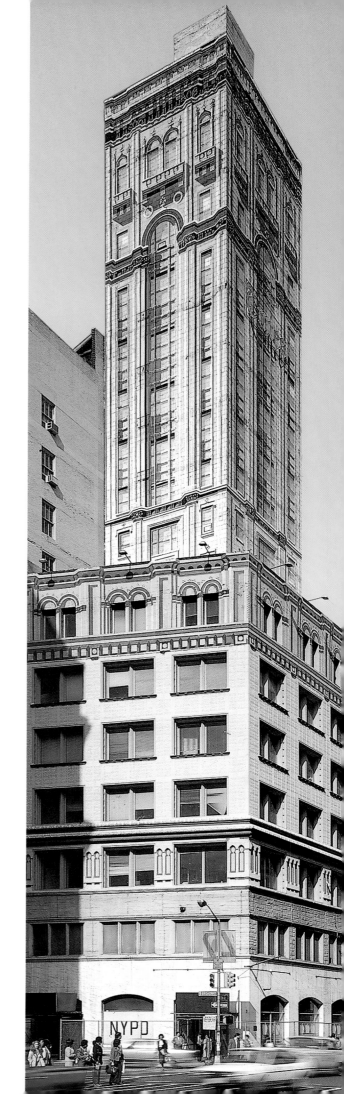

8 Crossroads Building (now defunct), 1465 Broadway at 42nd Street, New York City, New York, 1979
Oil paint, 12,000 square feet
Commissioned by the 42nd Street Redevelopment Project
Executed by Art Kraft Strauss Sign Corporation, New York

Formerly in the heart of Times Square, this building stood like a blank tube for sixty-eight years before
the artist painted three sides of it in a manner echoing the former Times Tower that was located in front of it.

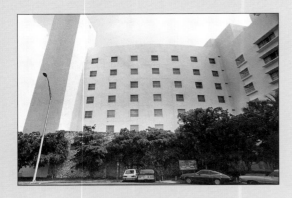

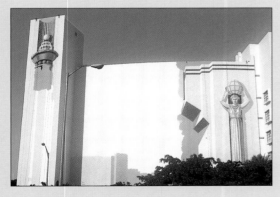

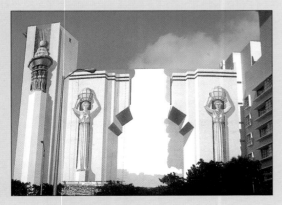

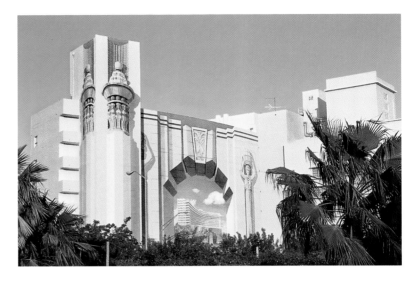

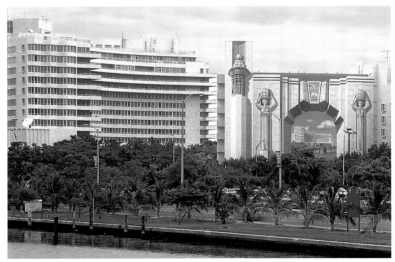

9 Fontainebleau Hotel, Miami Beach, Florida, 1985–86
Keim silicate paint on brick, 19,200 square feet
Commissioned by the Muss Corporation
Executed by American Illusion, New York

The large Art Deco "Arc de Triomphe" offers a view onto
the original Fontainebleau Hilton Hotel, designed by
Morris Lapidus, and is "lit" by two sixty-five-feet-high grand
lamps in the form of caryatids.

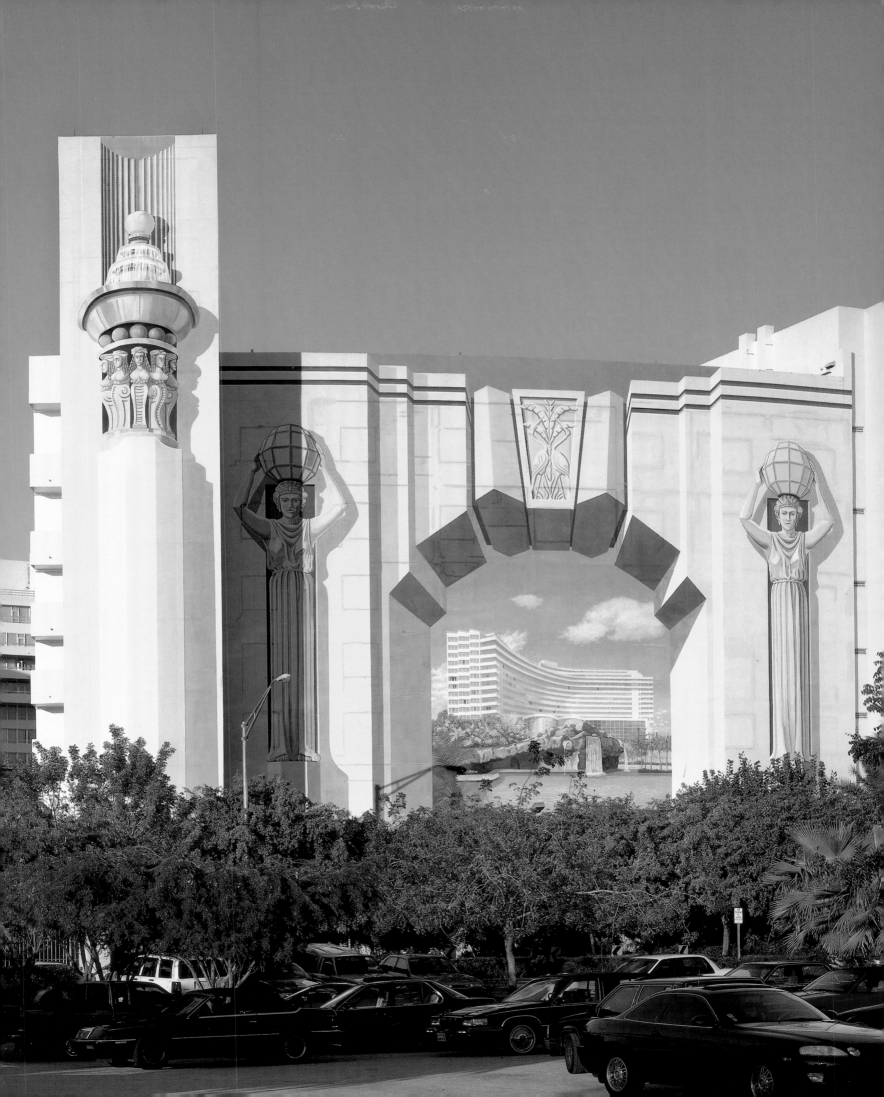

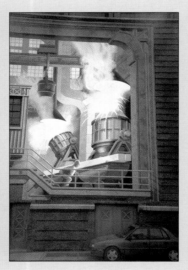

10 Fulton Theater (now Byham Theater), Pittsburgh, Pennsylvania, 1993
Keim silicate paint on brick, 9,000 square feet
Commissioned by the Pittsburgh Cultural Trust
Executed by Evergreene Painting Studios, New York

The back of this Neo-Edwardian theater (ca. 1910), located in the cultural district
of downtown Pittsburgh, was painted to simulate the interior of a steel mill,
a now nearly defunct business that was once the hallmark of this former "steel" city.

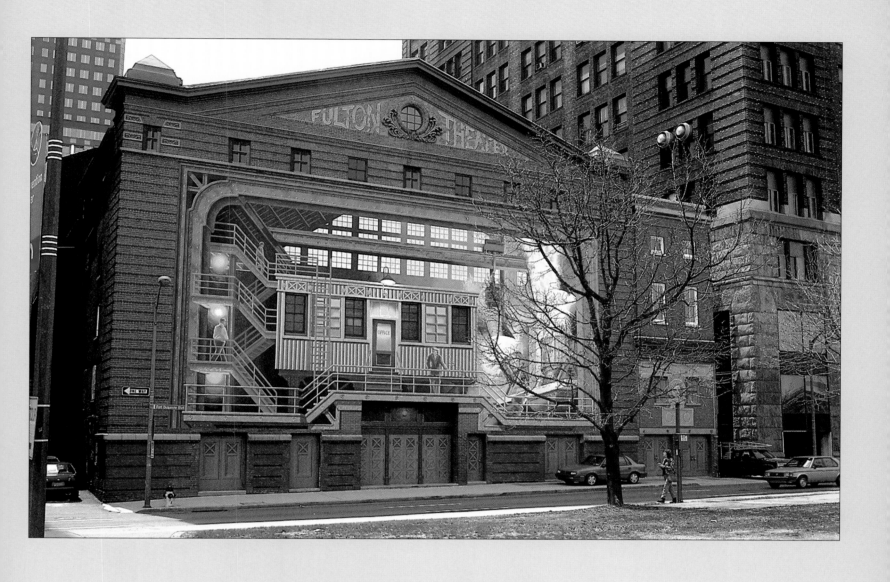

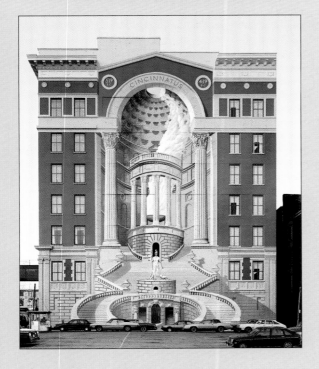

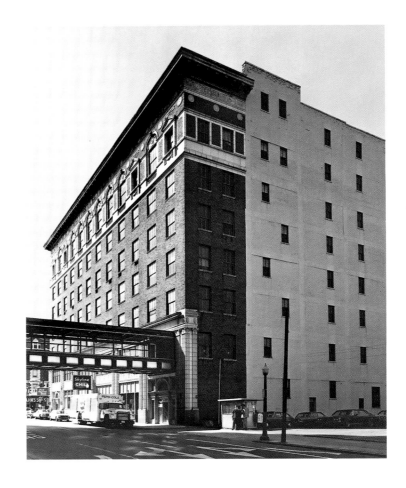

11 *Homage to Cincinnatus,* Brotherhood Building,
Kroger Company, Cincinnati, Ohio, 1983
Keim silicate paint on brick, 5,850 square feet
Commissioned by the Kroger Company, Cincinnati
Executed by Evergreene Painting Studios, New York

This mural, in downtown Cincinnati, is a monument to the Roman General
Cincinnatus, 519—439 B.C., after whom the city is named.

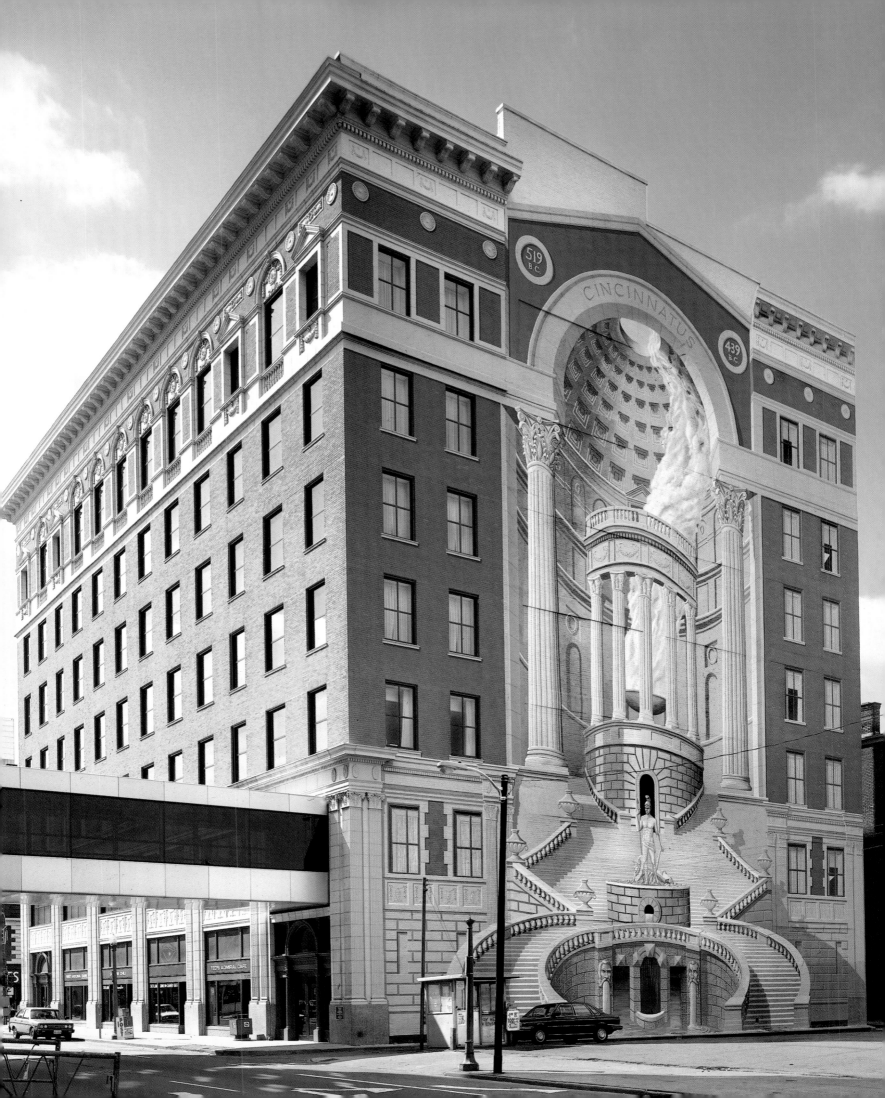

12 31 Milk Street, Boston, Massachusetts, 1986
Keim silicate paint on brick, 4,000 square feet
Commissioned by Windsor Buildings Associates
Executed by American Illusion, New York

This small wall on a side street in Boston contained thirty-three
diamond-shaped tie-rods which were incorporated into
the mural depicting a building under construction.

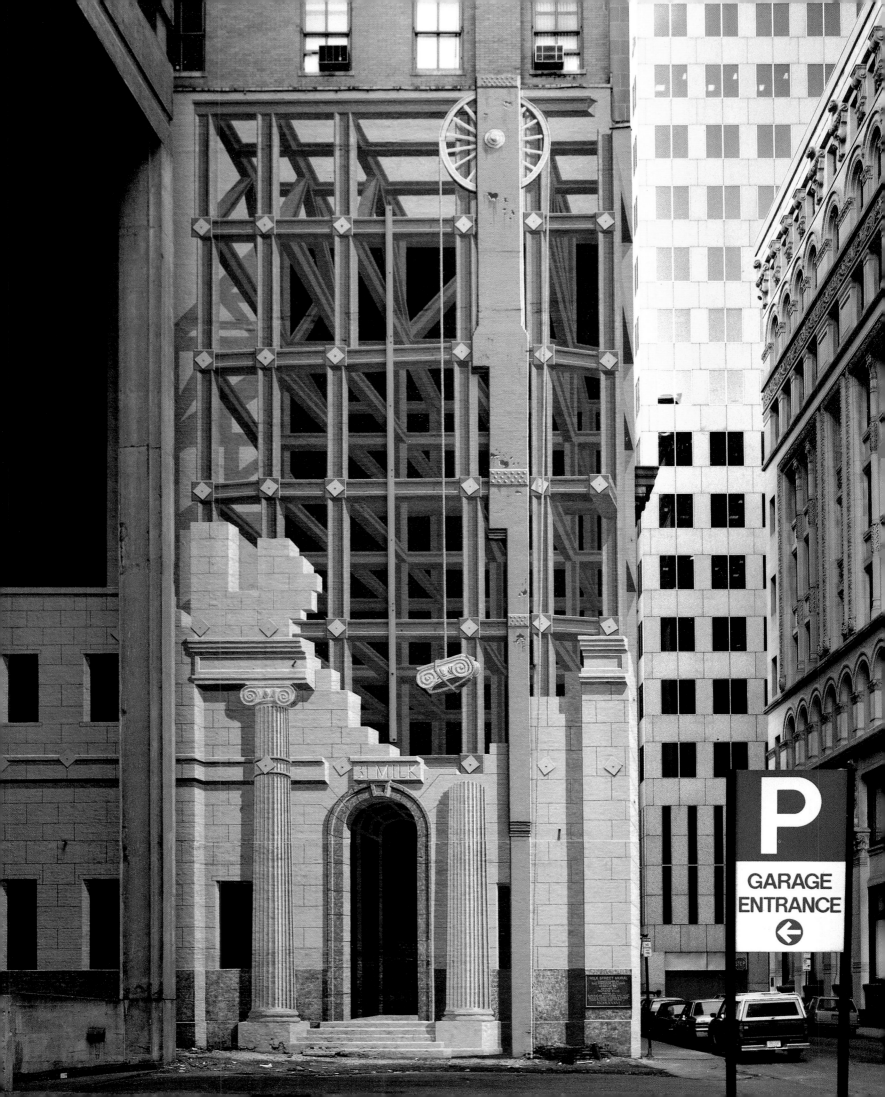

P

GARAGE
ENTRANCE

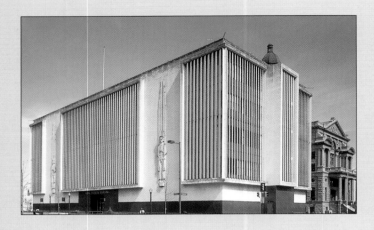

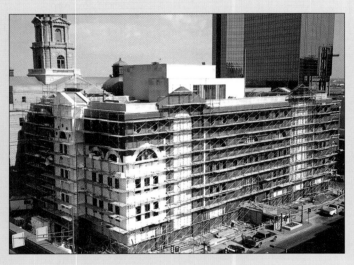

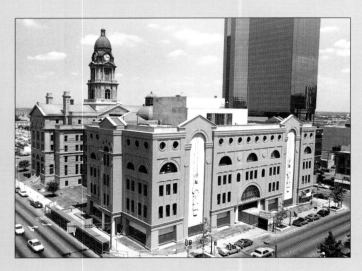

13 Tarrant County Courthouse, Fort Worth, Texas, 1988
Acrylic and Keim silicate paint, over 65,000 square feet
Commissioned by Tarrant County with funds from
the Sid Richardson Foundation, Fort Worth, Texas
Executed by American Illusion, New York

This facade reconstruction and mural, on four sides of a courthouse annex,
is the most complicated project ever undertaken by the artist. It was completed
with assistance from the architect George Woo. The artist designed a dryvit skin—
a polymer and stone pumice material mounted on Styrofoam, with several
openings to reveal windows—to cover the original 1952 building. The resulting
changes to the annex's design and color were intended to make it more harmonious
with its elegant 1890 *sandstone* neighbor.

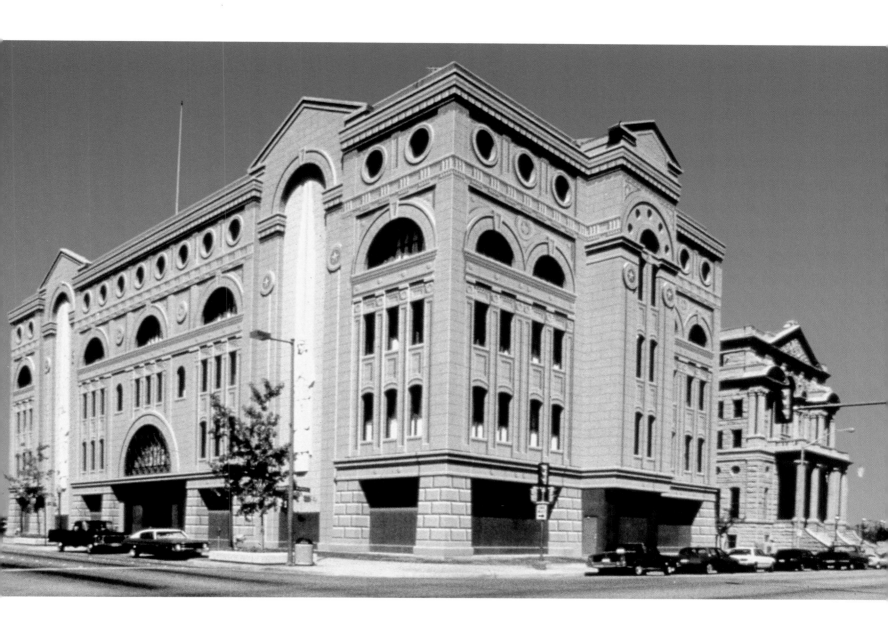

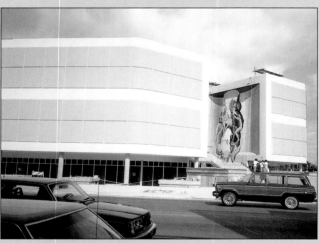

14　The Bakery Center (no longer extant), South Miami, Florida, 1985–86
Keim silicate paint, each wall 1,200 square feet
Commissioned by Martin Margolis
Executed by American Illusion, New York

When asked by the building's owner to enhance the entrance to a new
shopping mall, the artist painted two faux sculptural ensembles,
with water flowing through them, that relate to Neptune's Fountain on
the Piazza Navona, Rome, by Gianlorenzo Bernini.

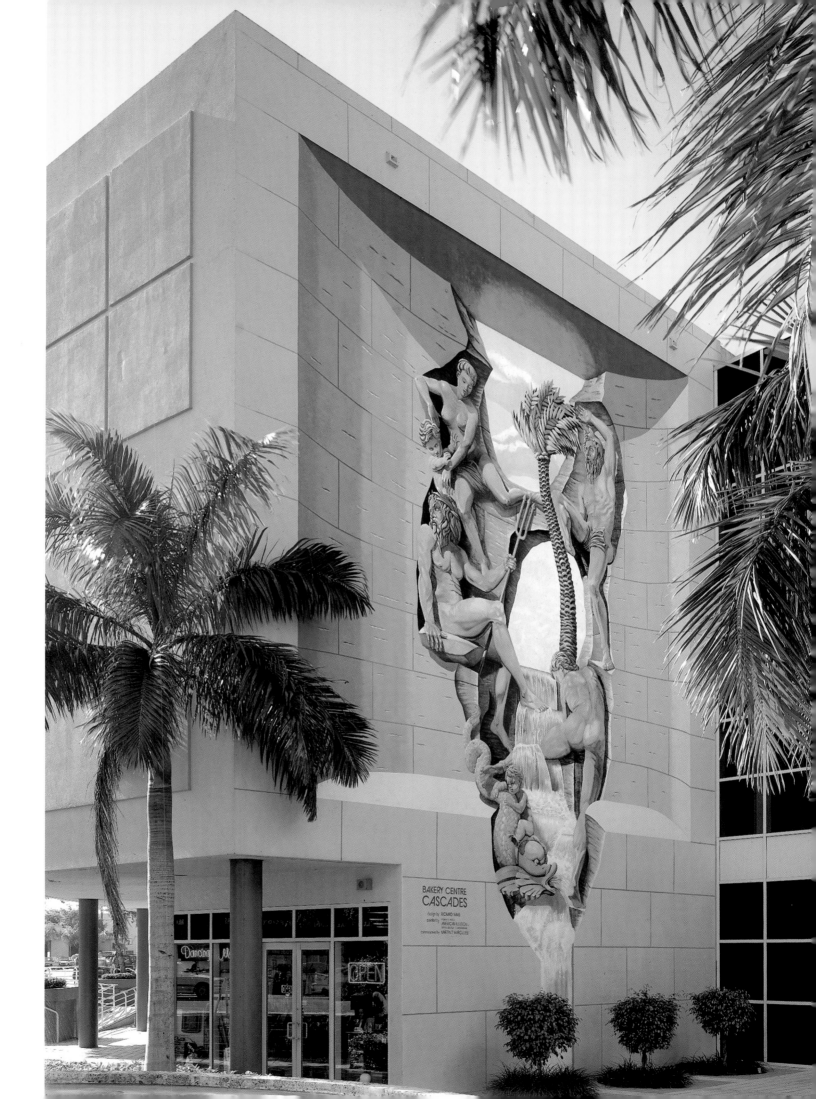

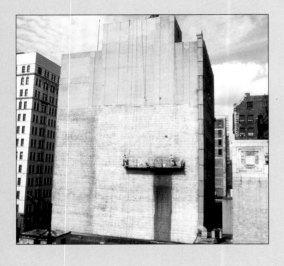

15 Centre Theater, Milwaukee, Wisconsin, 1981
Keim silicate paint, 9,600 square feet
Commissioned by Milwaukee Downtown Redevelopment Corporation
Executed by Evergreene Painting Studios, New York

The Art Deco painting on this facade recalls the three-dimensional
facade of the former Grand Theater in downtown Milwaukee,
which the artist knew as a child. The large window reflects the
image of the Pabst building, which was razed prior to the painting
of the mural.

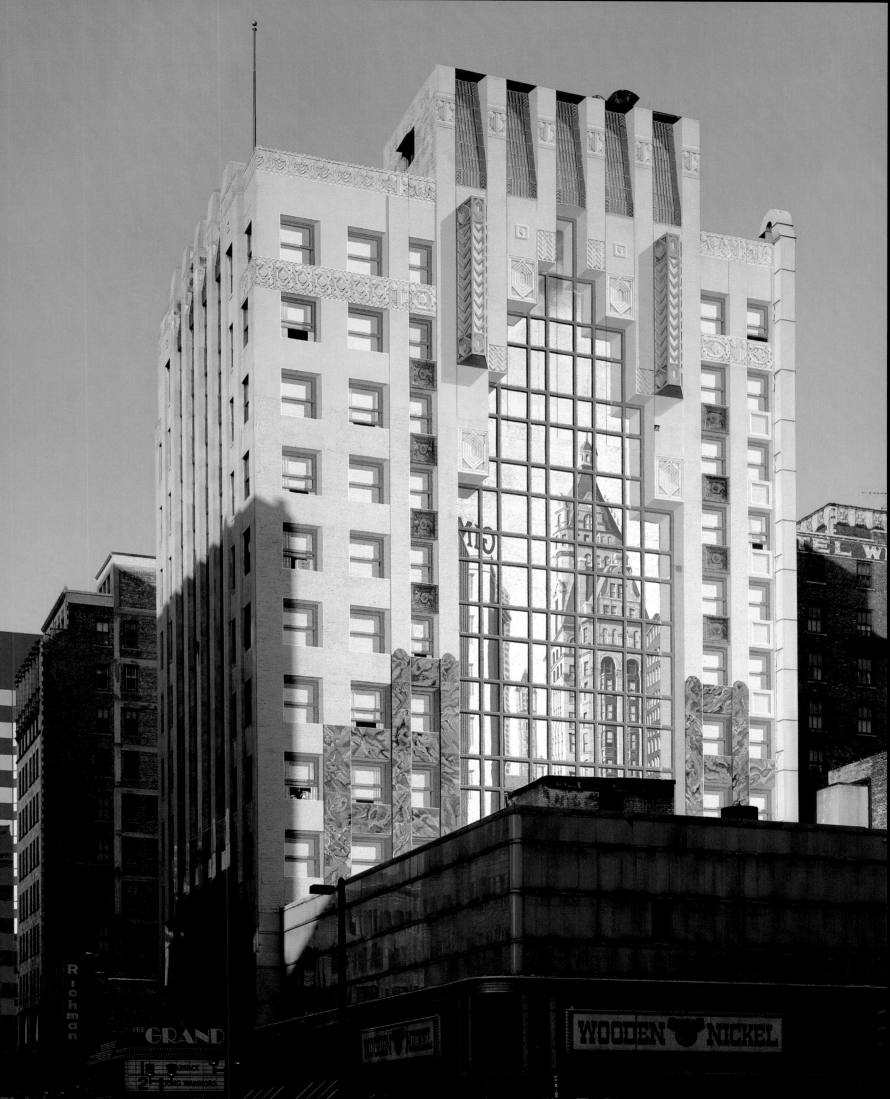

16 Zwingerstrasse, near Isar Tor, Munich, Germany, 1978
Keim silicate paint, 4,500 square feet
Commissioned by Lloyd Insurance Company and the City of Munich
Coordinated by Galerie Biedermann, Munich

This facade not only wraps around the front of the building
but also creates a "porch" that looks into a hidden courtyard
with a small "garage," whose open door provides a glimpse of
a 1932 model of a Mercedes Benz.

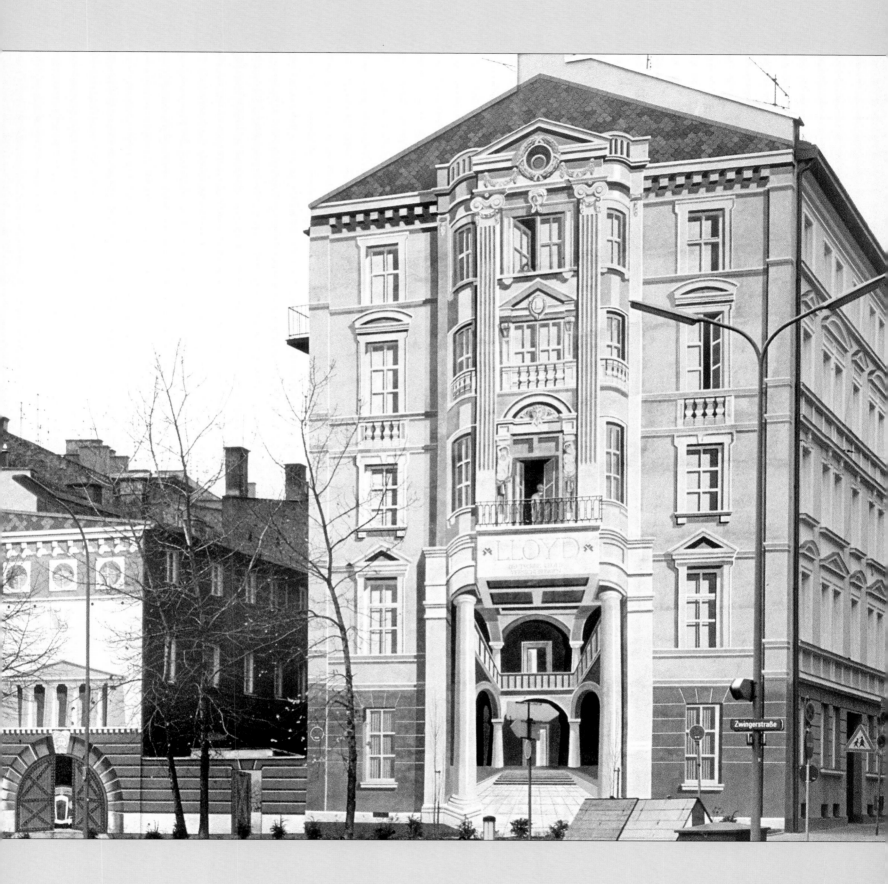

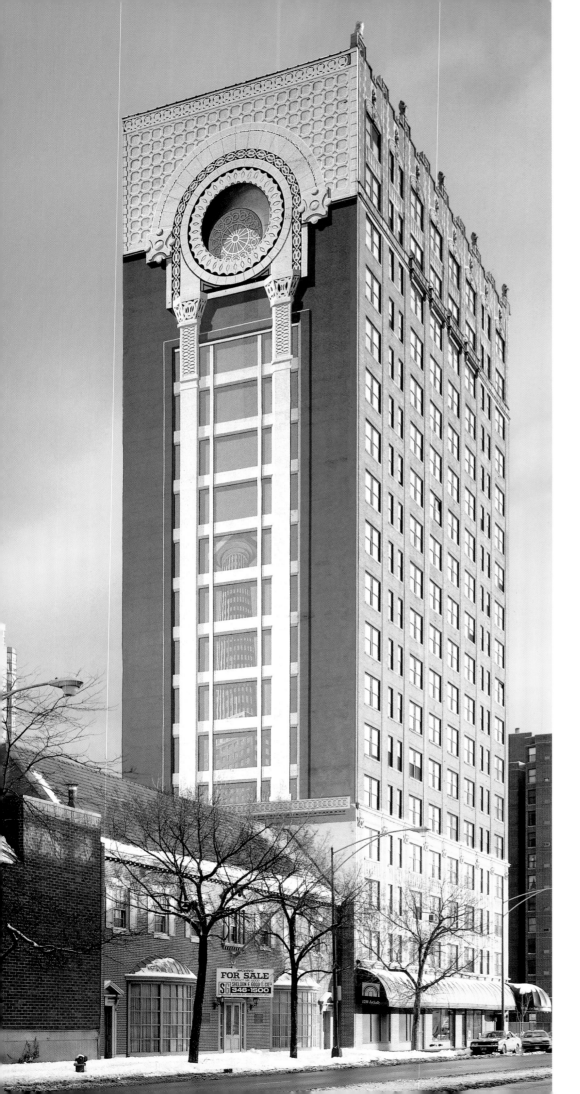

17 *Homage to the Chicago School,* 1211 North LaSalle Street, Chicago, Illinois, 1980
Keim silicate paint, 18,000 square feet
Executed by Evergreene Painting Studios, New York

The mural, which is painted on three sides of an eighteen-floor apartment house, follows the color and lines of the finished front facade and reflects Louis Sullivan's decorative style.

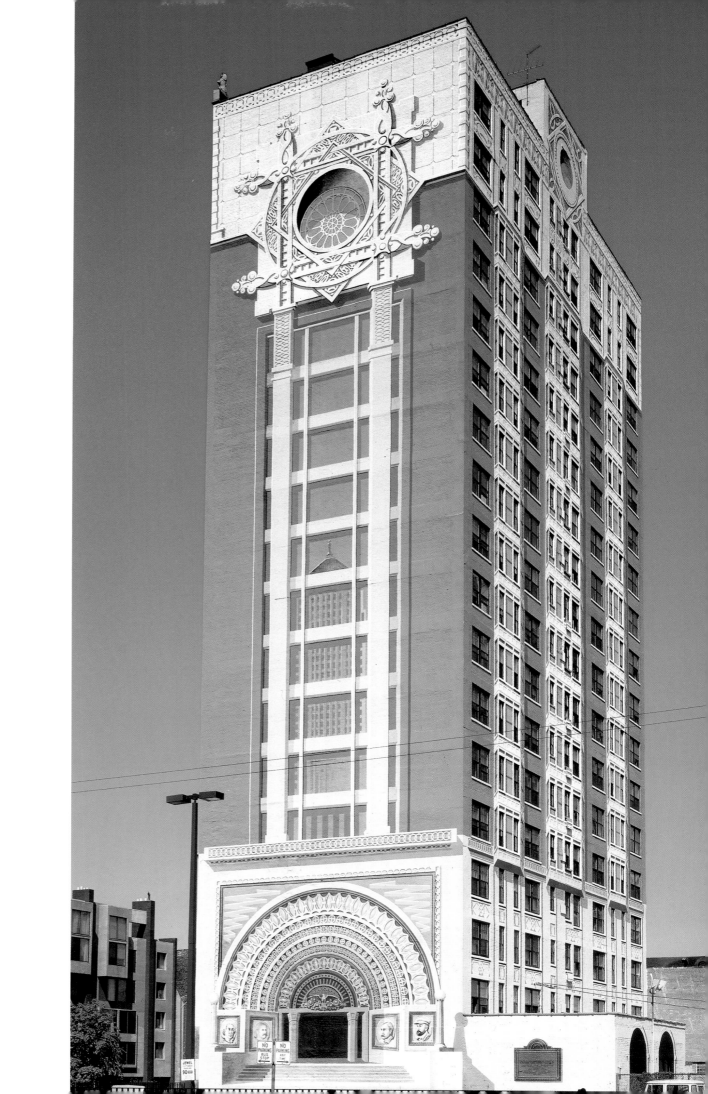

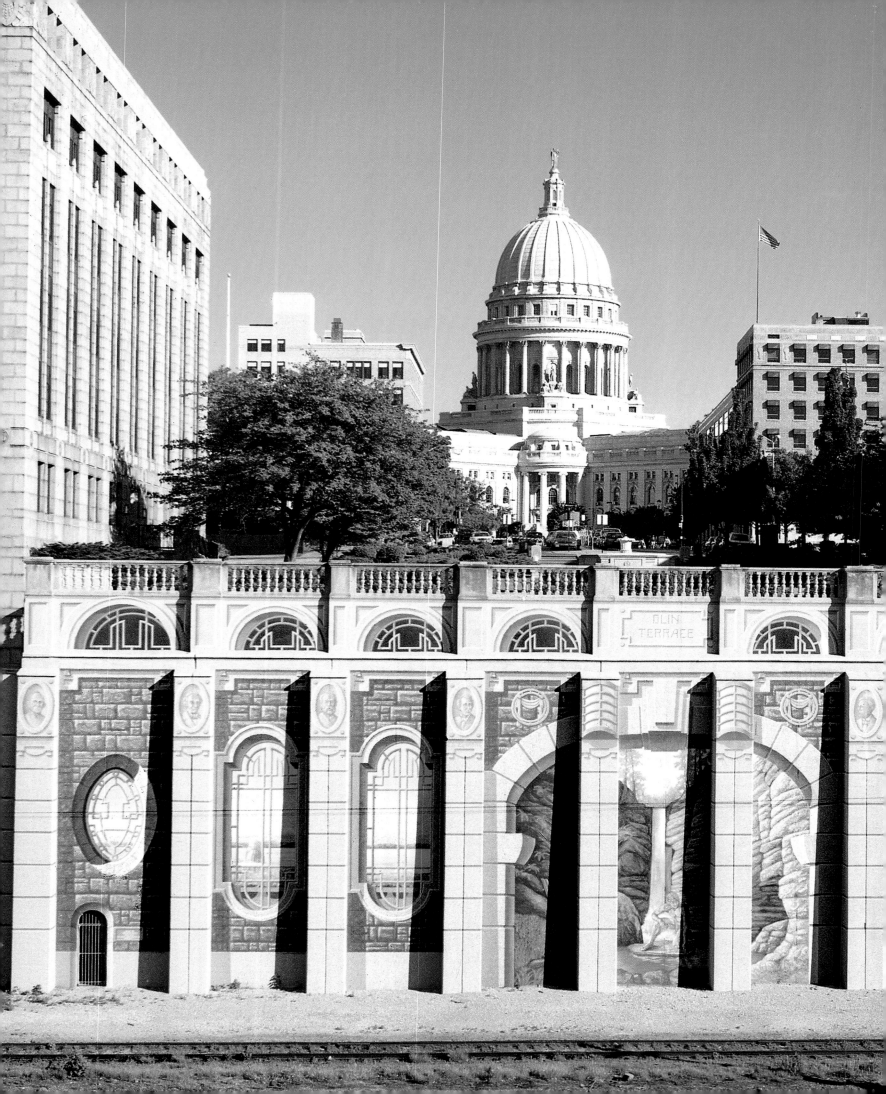

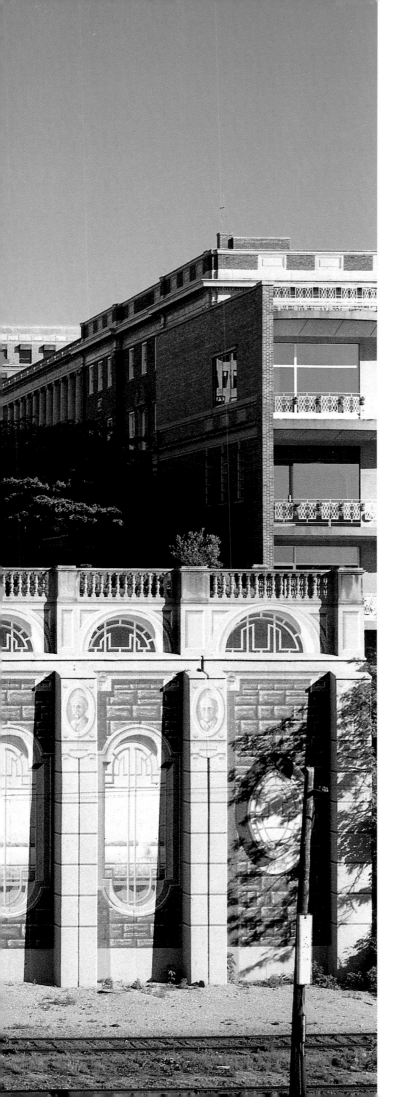

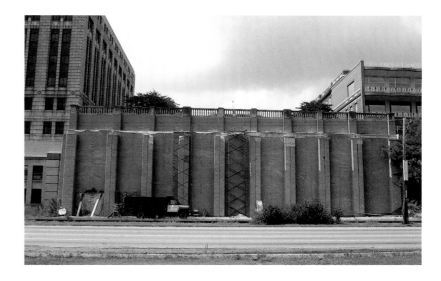

18 The Olin Terrace, Madison, Wisconsin, 1987
Keim silicate paint, 4,800 square feet
Commissioned by the City of Madison
Executed by American Illusion, New York

The artist chose this site specifically because it was the rejected site of
Frank Lloyd Wright's proposed Convention Center. The Center had been turned
down by the City on three different occasions since the early 1940s.
When Haas undertook the mural project, he assumed the Center would never
be built, but a revised version of it was completed in 1995. In the mural,
a reflection of Wright's project could be seen in the painted windows.
The mural was covered over when the City of Madison built the Convention
Center.

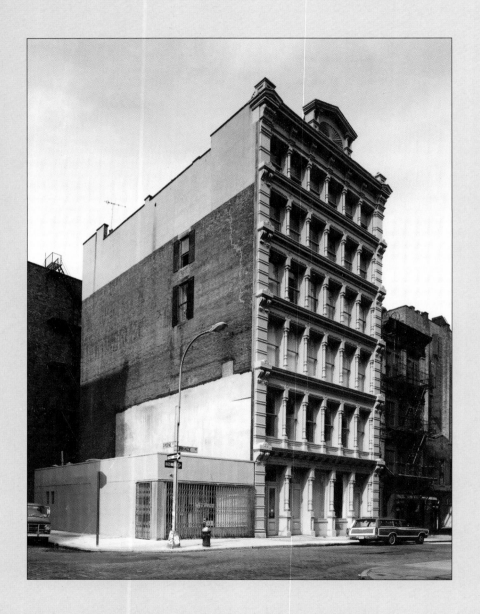

19 112 Prince Street, New York City, New York, 1975
Oil paint on brick and cement, 8,970 square feet
Commissioned by Citywalls, Inc., New York
Executed by Van Wagner Outdoor Advertising, New York City, New York

The cast iron wall of the front of this building is repeated in the mural on its east wall.
The mural also incorporates two pre-existing windows and features a cat painted into
another window. This was the first outdoor mural completed by the artist and was coordinated
by Doris Freedman, the director of Citywalls, who was instrumental in launching many of
the artist's early projects.

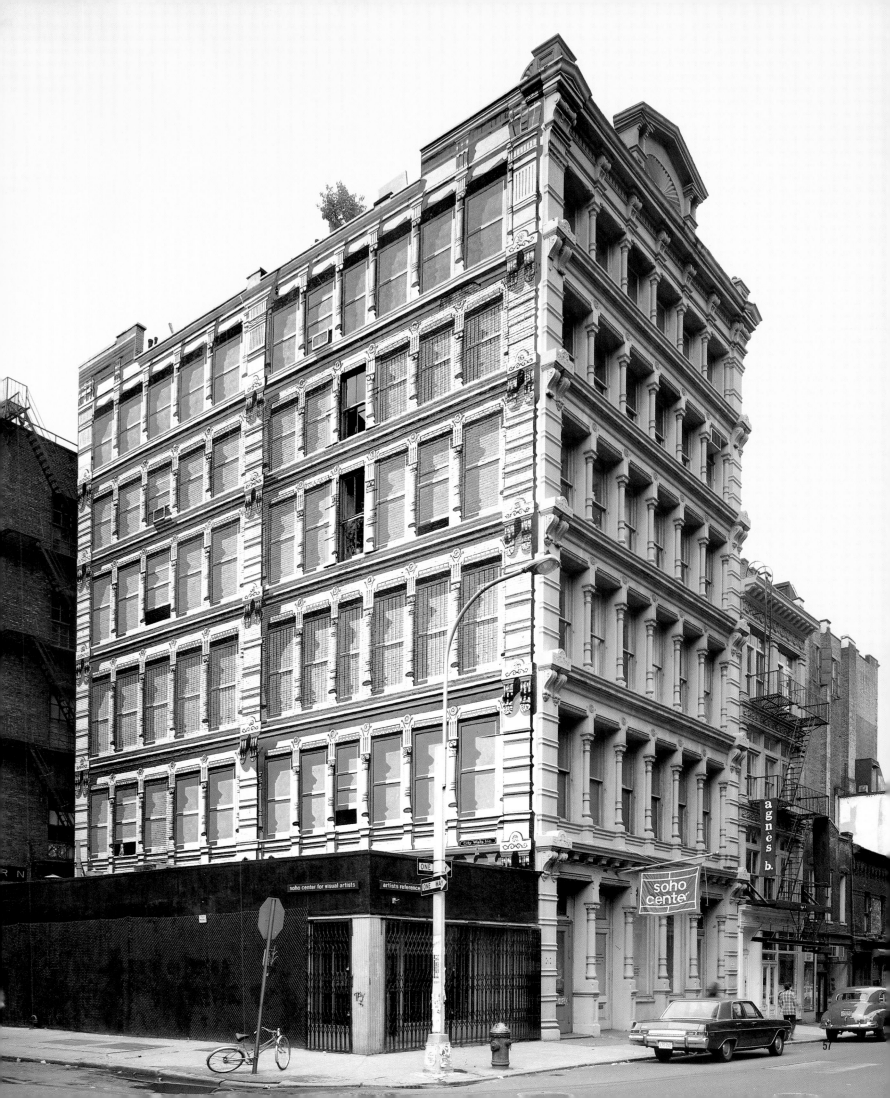

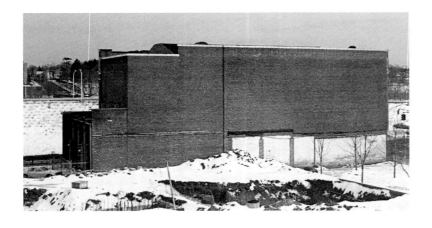

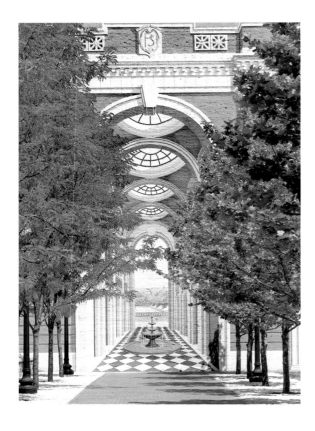

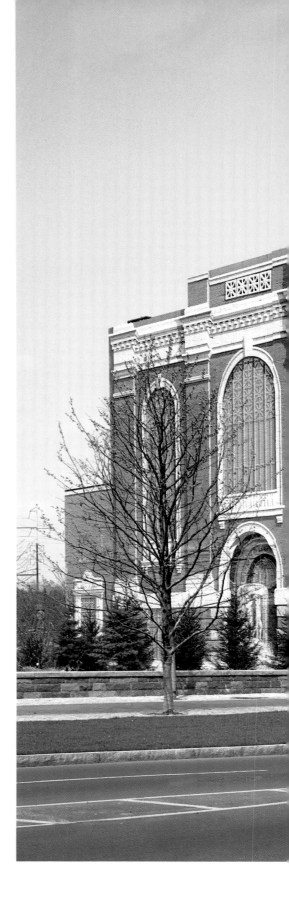

20 P.S.E. & G. Electric Substation (no longer extant), New Brunswick, New Jersey, 1982
Keim silicate paint on brick and cement, 6,000 square feet
Commissioned by Johnson & Johnson Corporation
Executed by Evergreene Painting Studios, New York

The commissioned mural on this substation remained in existence until I.M. Pei completed his redesign of the Johnson & Johnson Headquarters complex in 1990.

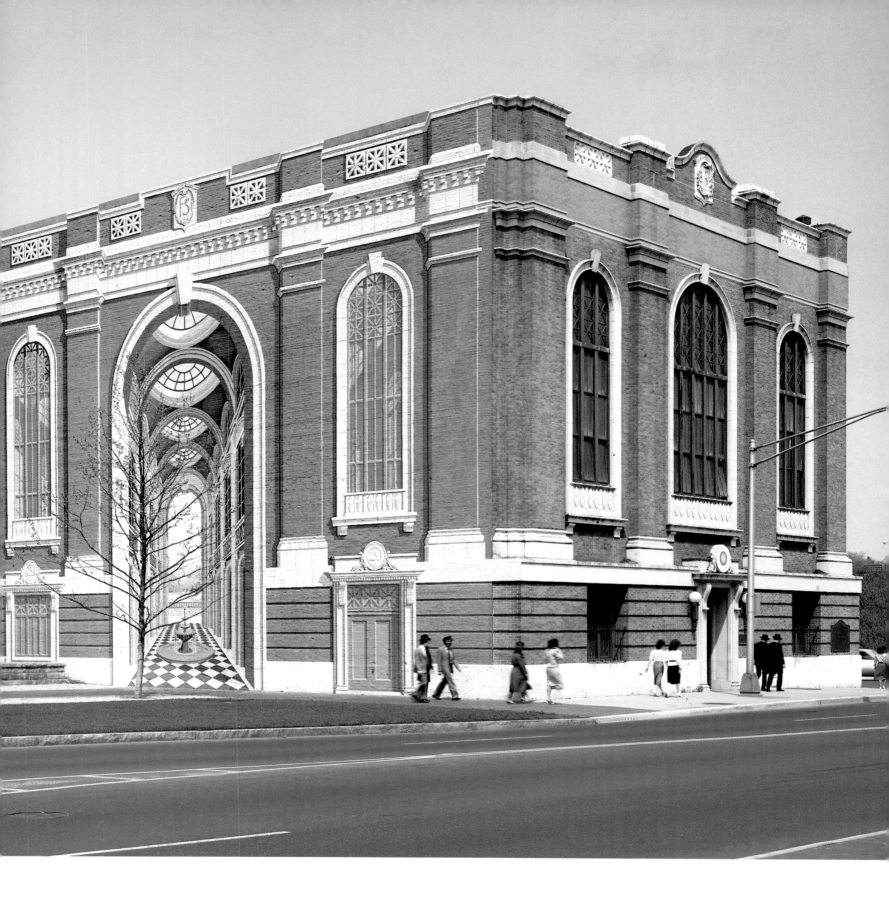

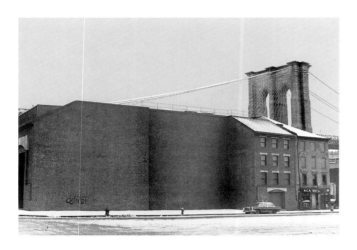

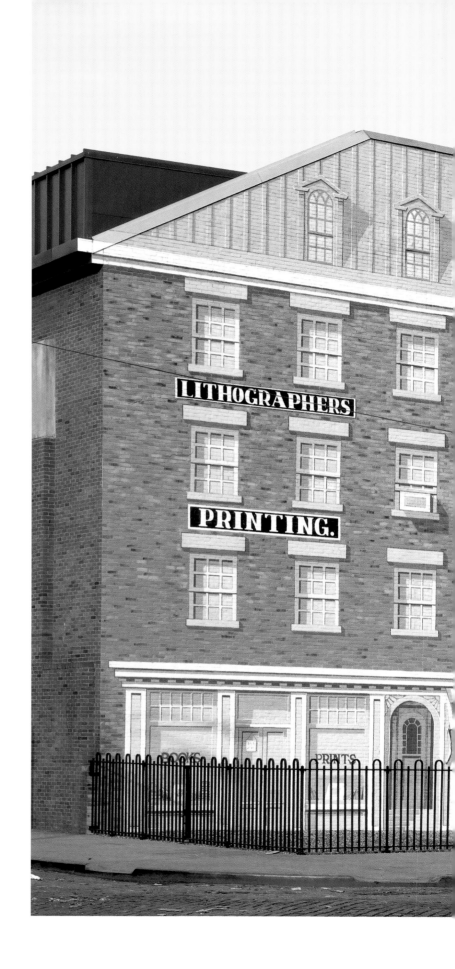

21 Peck Slip Arcade, South Street Seaport, New York City, New York, 1978
Oil paint on brick, 6,000 square feet
Commissioned by Consolidated Edison, New York
Coordinated by Citywalls, Inc., New York
Executed by Seaboard Outdoor Advertising, New York

Trompe l'œil facades and a view of the nearby Brooklyn Bridge,
appropriate to early nineteenth-century New York, cover the south wall
of this Con-Ed substation.

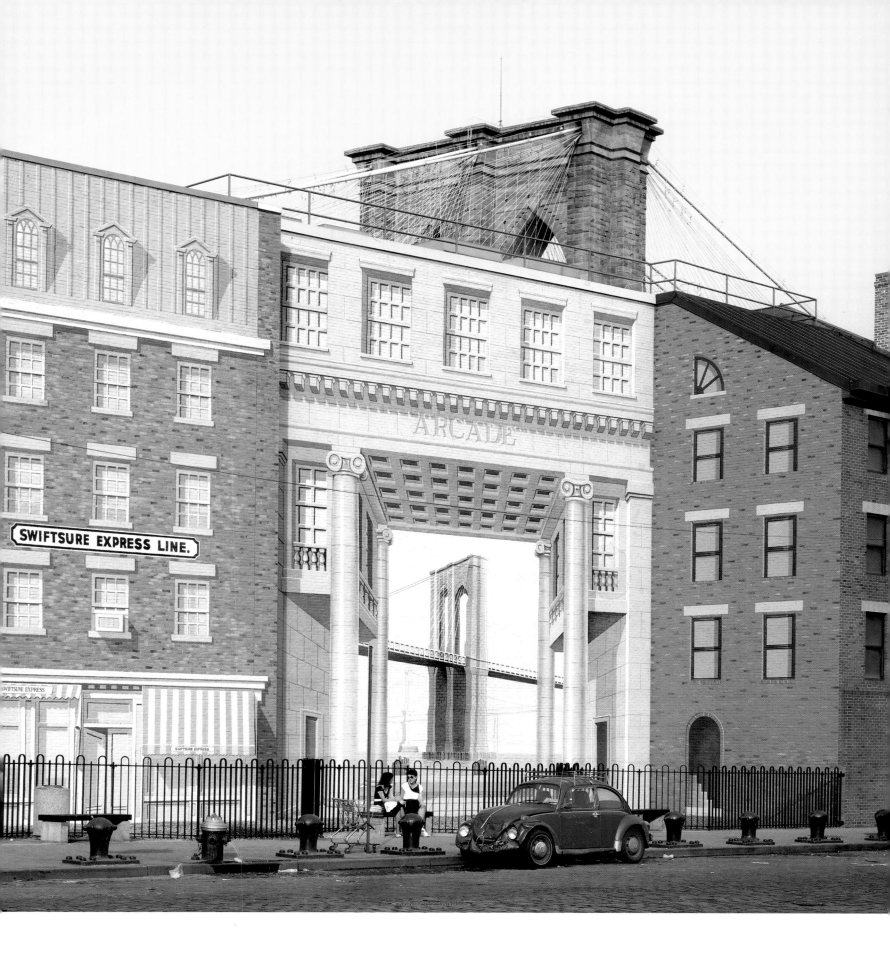

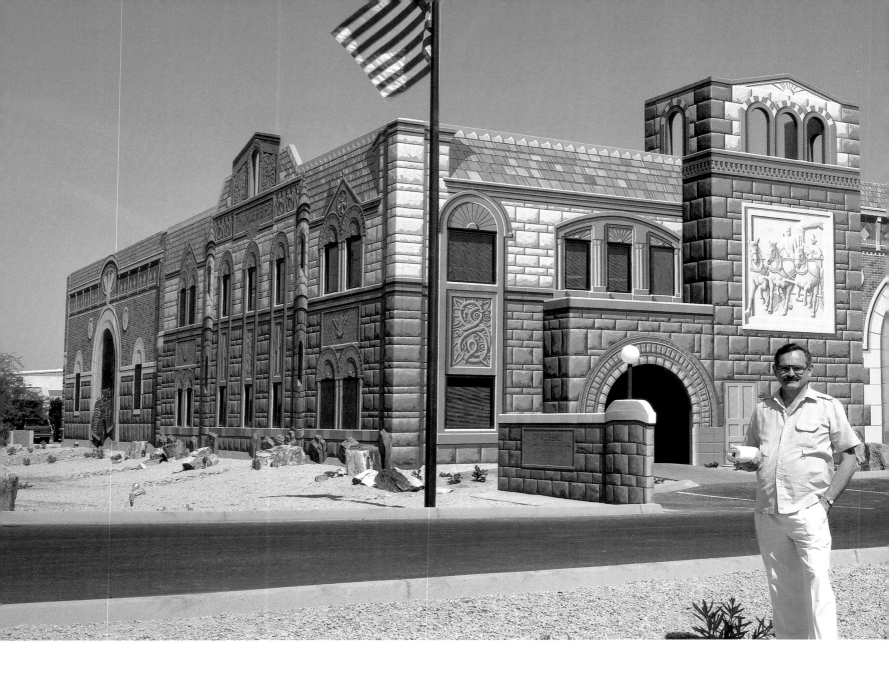

22 Thunderbird Fire & Safety Equipment Corporation, Phoenix, Arizona, 1985
Keim silicate paint on cement, 8,000 square feet
Commissioned by Fred Nachman III, owner
Executed by American Illusion, New York

This "tilt-up" building was partly shaped on the ground—cement
was poured and the building walls were tilted up and joined—in order to
support the artwork it bears, a painting of a turn-of-the-century fire station.

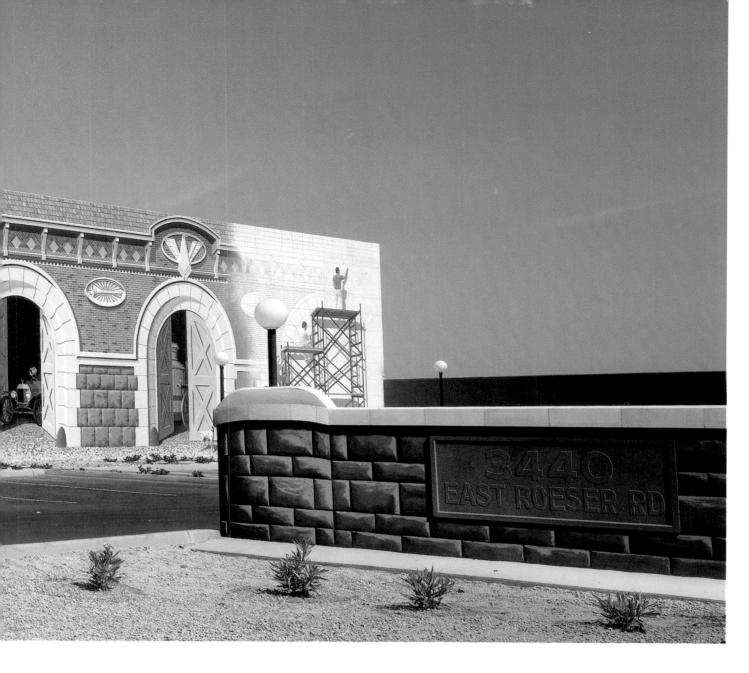

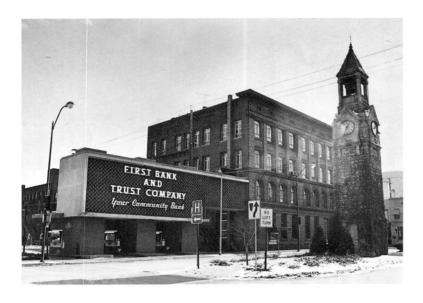

23 The First Bank and Trust Company of Corning, New York, 1982
Oil paint on cement, 750 square feet
Commissioned by the First Bank and Trust Company of Corning, New York
Executed by Seaboard Outdoor Advertising, New York

In an effort to link old with new in a harmonious fashion, the artist resurfaced
the bank's 1950s drive-through and reproduced the stone facade and color of its
late nineteenth-century predecessor.

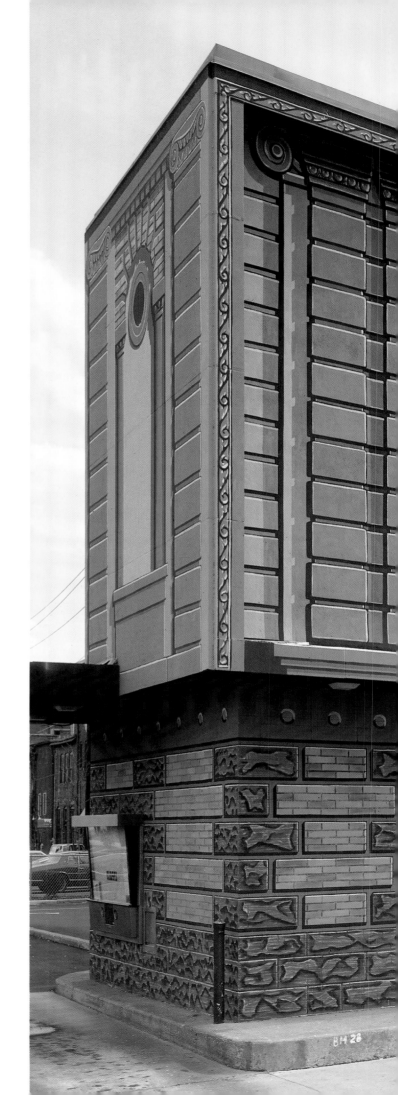

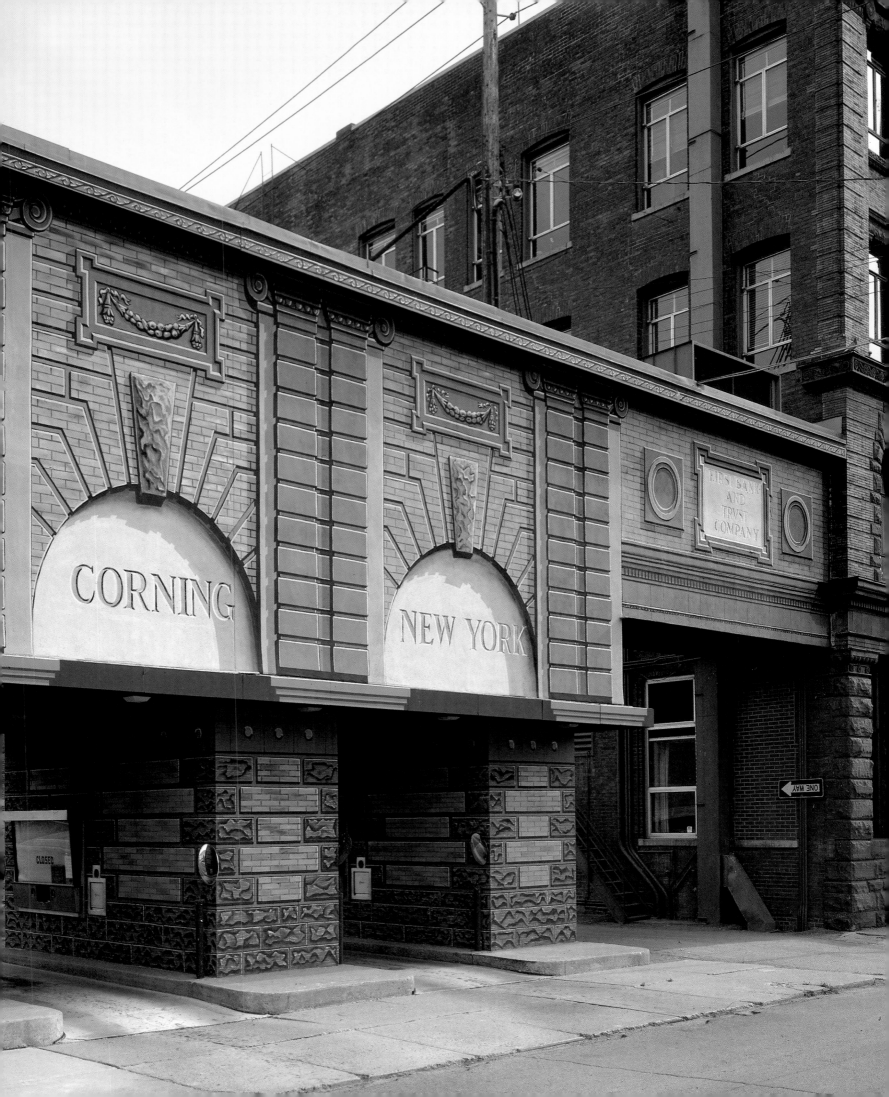

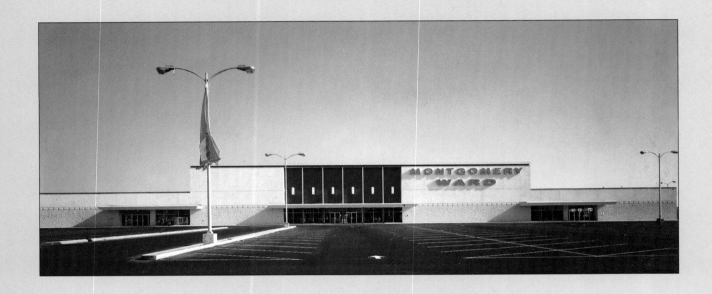

24 Montgomery Ward Department Store, Fullerton, California, 1985
Keim silicate paint, 10,000 square feet
Commissioned by Montgomery Ward Co.
Executed by Evergreene Painting Studios, New York

The first commission in a pilot program from which no other projects evolved,
this department store was transformed into a Mayan temple, reflecting the heritage
of the mostly Hispanic neighborhood in which it is located.

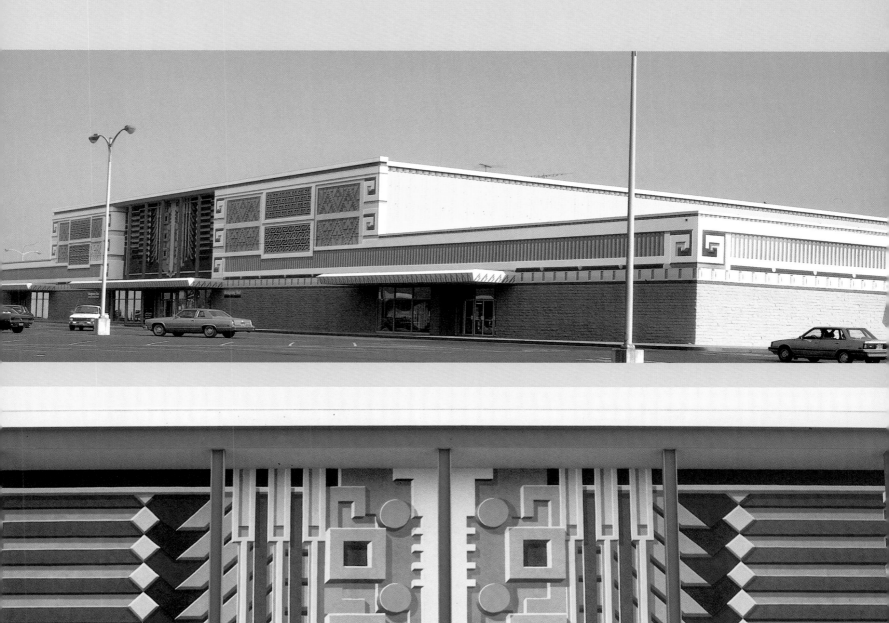
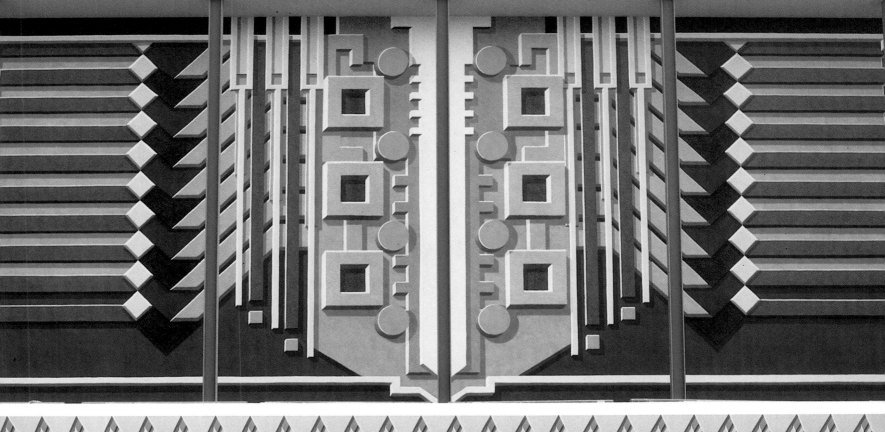

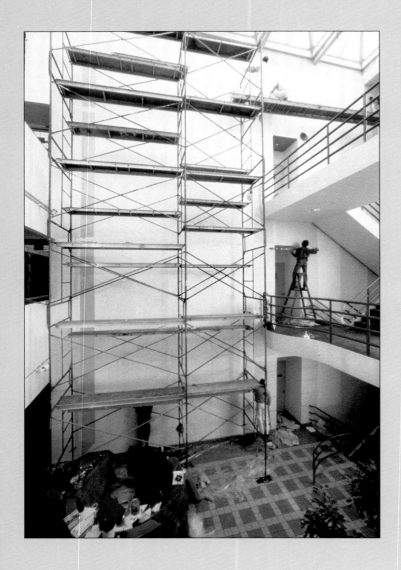

25 Meredith Communications Headquarters, Des Moines, Iowa, 1980
Acrylic paint, 1,200 square feet
Commissioned by Meredith Communications and Charles Herbert and Associates
Executed by Evergreene Painting Studios, New York

In this project, a building from the 1920s was linked with another from the 1980s by
an atrium in which the artist integrated the two different styles of architecture.

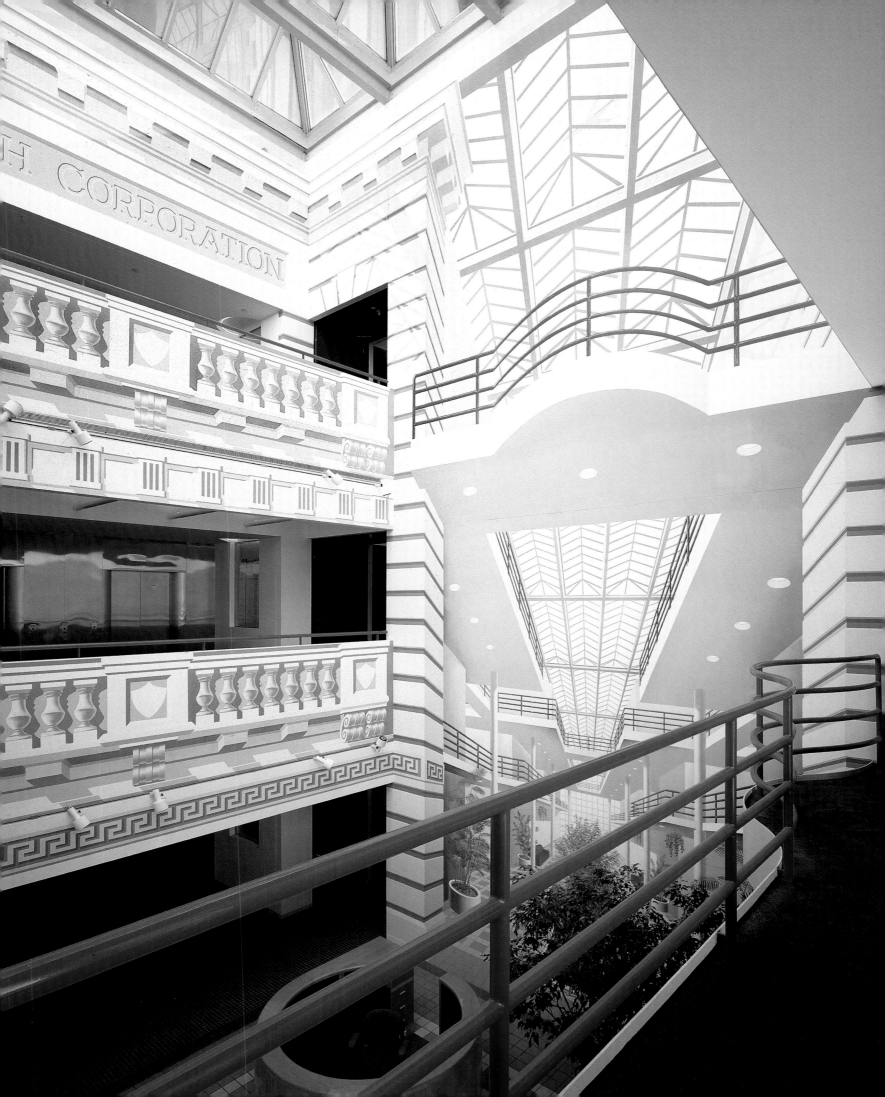

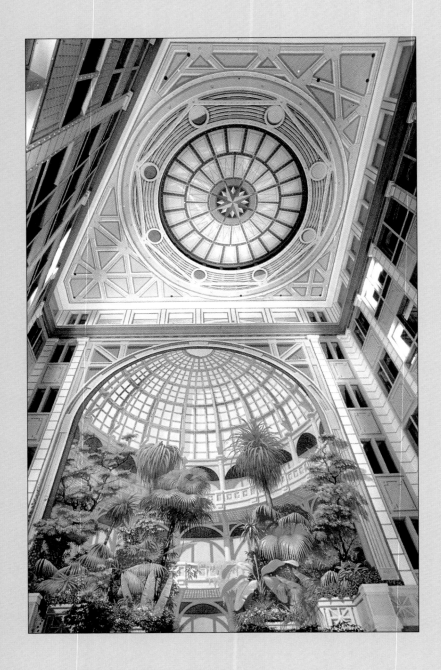

26 101 Merrimac Street, Boston, Massachusetts, 1990
Acrylic paint, 4,000 square feet
Commissioned by London and Leeds Development Corporation
and TAC Architects
Executed by American Illusion, New York

This is the most ambitious interior project the artist has
worked on to date, covering all the walls and the entire
ceiling of a large atrium. The artist worked closely with the
building's architects to blend together built and painted areas.

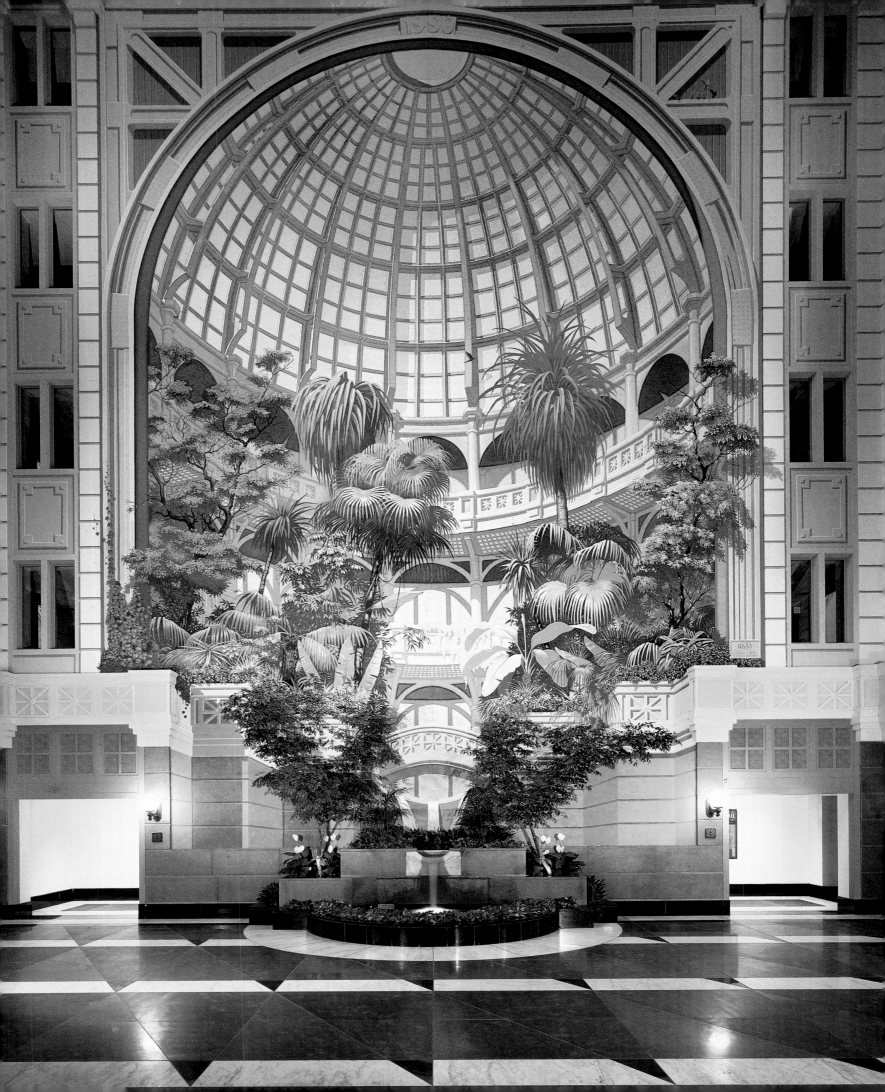

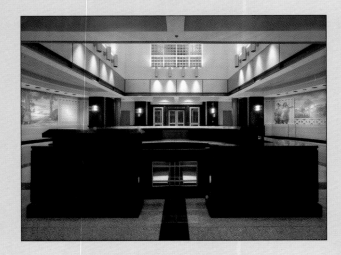

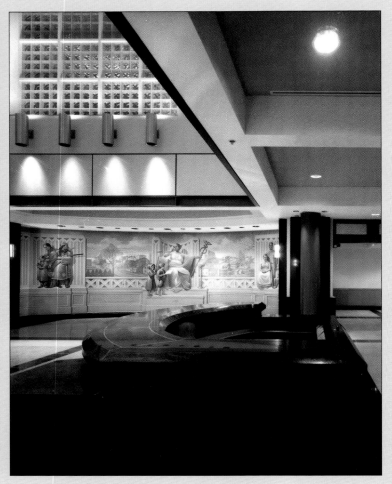

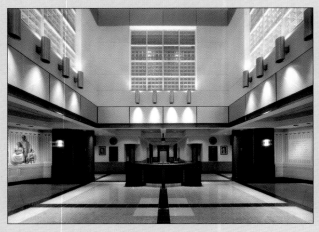

27 Federal Building and U.S. Courthouse, Kansas City, Kansas, 1994
Acrylic paint on two panels, each 320 square feet
Commissioned by the Percent for Art funding program of the
General Services Administration of the United States Government
Architect: Gossen, Livingston Architects, Witchita, Kansas
Executed by Thomas Street Studios, Providence, Rhode Island

Each panel is executed in faux blue-and-white ceramic tile and illusionistic
terra cotta sculpture. As a pair, the panels depict the conflicts between
Native Americans and the farmers who settled Kansas in the late nineteenth century.

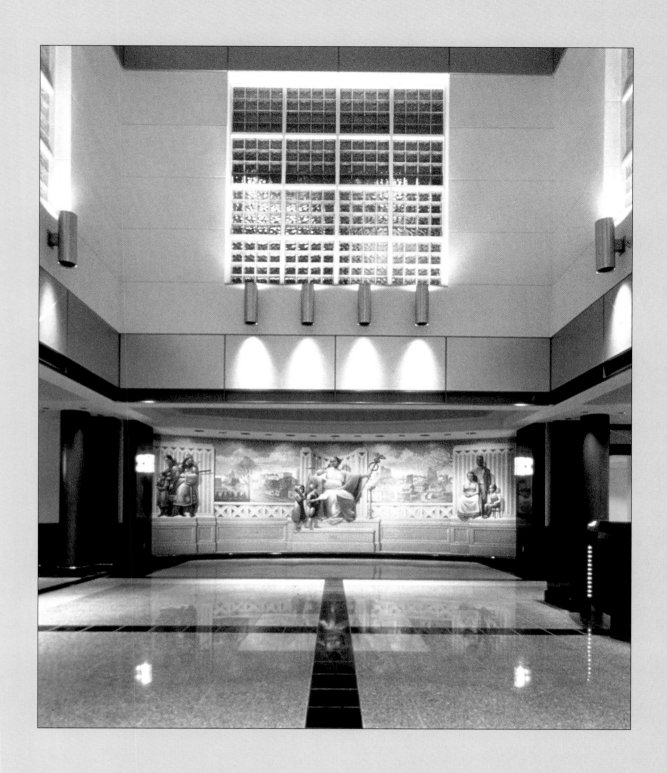

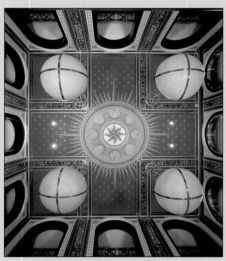

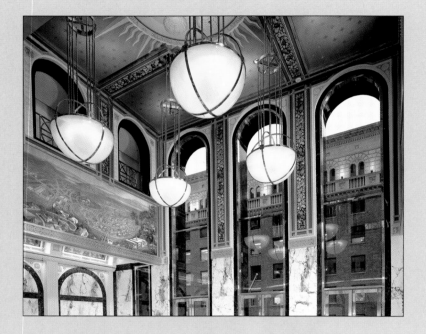

28 Sky Lobby, Home Savings of America Tower, Los Angeles, California, 1988
Acrylic and oil paint and computer-generated print, 3,000 square feet
Commissioned by Ahmanson Commercial Development Co., architect Tim Vreeland,
and art consultant Tamara Thomas
Executed by American Illusion, New York

This complex interior project involved the application of three murals around
the upper wall area of the lobby: an idealized Los Angeles landscape,
a painted grape arbor in the surrounding arcade, and a star-studded sky
on the ceiling.

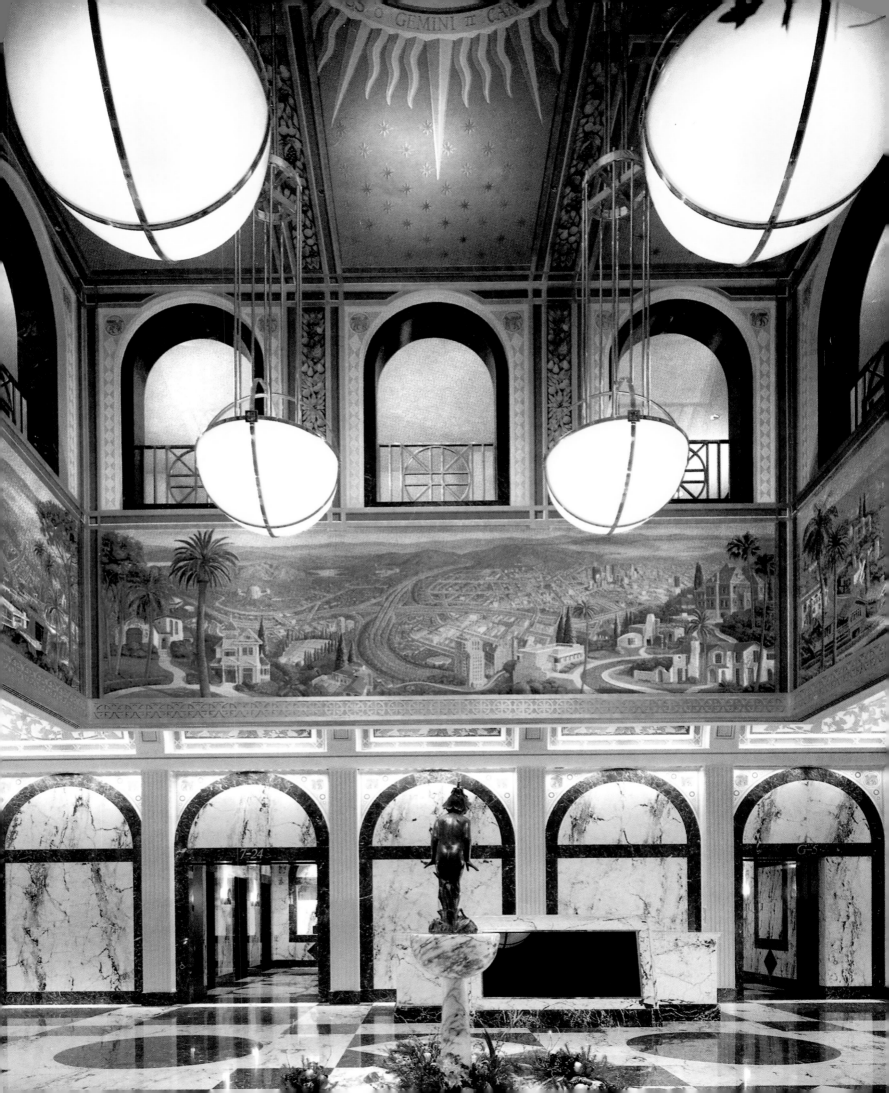

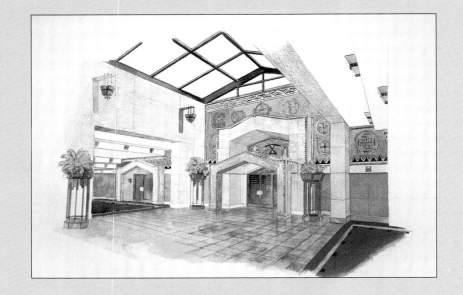

29　Western Savings and Loan Association
Corporate Headquarters,
Phoenix, Arizona, 1987
Acrylic and oil paint, 2,500 square feet
Commissioned by Cornoyer-Hedrick Architects
and Planners, Phoenix, Arizona
Executed by American Illusion, New York

This ballroom and banquet hall is attached to
an office complex that is directly
across the street from Frank Lloyd Wright's
Biltmore Hotel which, along with native
Anasazi sand paintings, inspired the building's interior.
left: details of banquet and entrance halls before painting
right: watercolor study of completed entrance hall

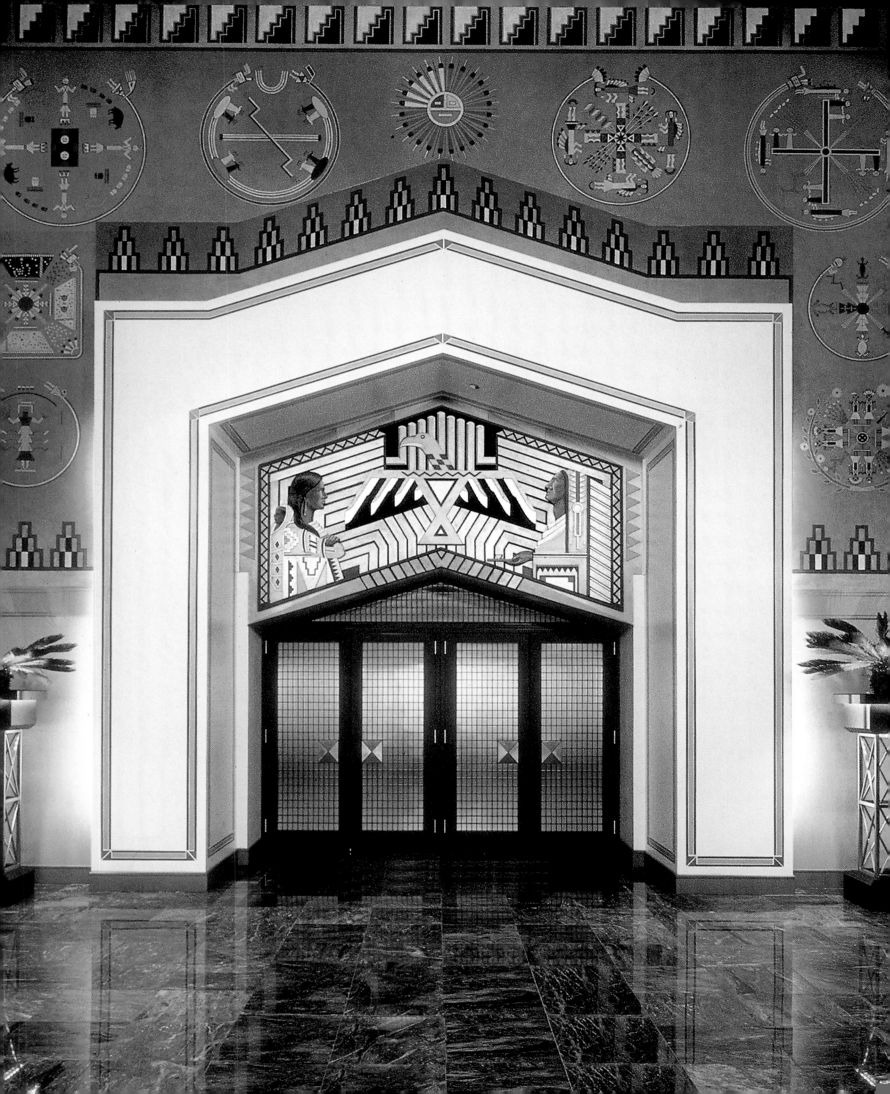

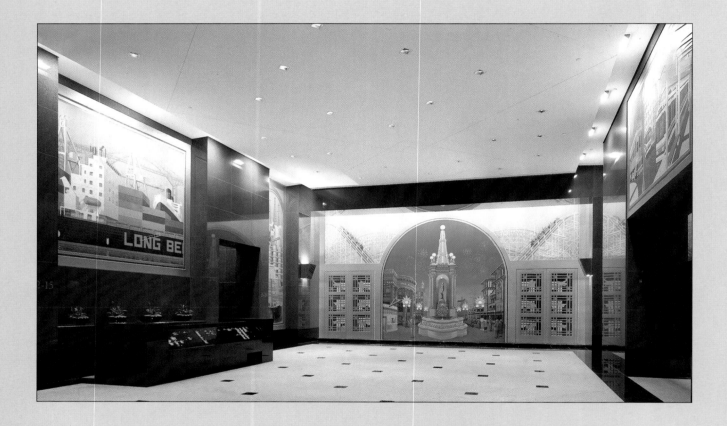

30 Landmark Square, Long Beach, California, 1991
Acrylic and oil on canvas
Commissioned by Cushman Investment and Development Co.
Coordinated by Tamara Thomas Fine Art Service
Executed by American Illusion, New York

For the lobby of Landmark Square, a skyscraper located twenty miles south of Los Angeles in Long Beach, the artist
painted five murals relating to the area's history as a resort and manufacturing center. Two vertical panels depict airplane
manufacturing and oil drilling and refining, primary industries in the area until recently. Another panel relates to Long
Beach's importance as a port and includes a picture of the Queen Mary, which is still used as a museum and hotel.

Catalogue

1 Robert S. Byrd Federal Building and
 U.S. Courthouse, Beckley, West Virginia, 1999
The figure of Justice is surrounded,
on four walls, by views of the flora
and fauna of West Virginia.

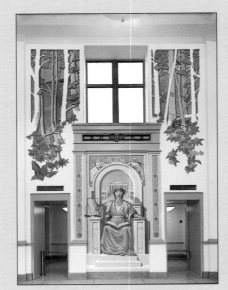
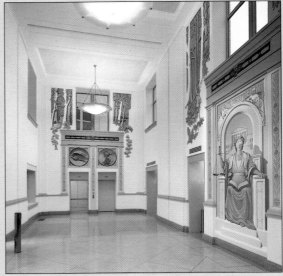

2 *Pergola of Justice,* Sarasota County Courthouse,
 Sarasota, Florida, 1998
Here a series of three-dimensional arcades,
with cut-out pergolas, frame an image of
Justice and garden foliage. Each arcade
is lit from above and from the sides to
heighten viewers' perception of depth and
give a sense of space in what is otherwise
a narrow hallway.

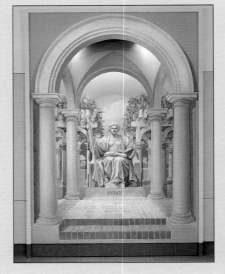
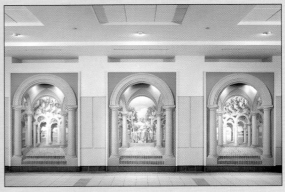

3 Absoluthaas, Chicago, Illinois, 1996
TBWA/Chiat Day produced this
computerized image from the
artist's painting for their Absolut
advertising campaign in 1996.
The mural refers to the architectural
style of Louis Sullivan and remained
for one year on Ontario Street
in Chicago, Illinois.

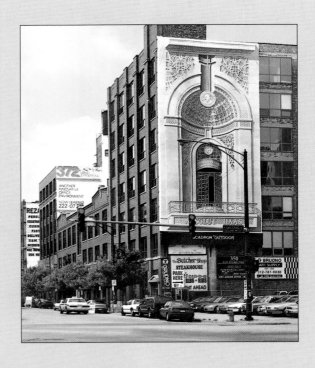

4 Absoluthaas, New York City, New York, 1996

The subtle outline of an Absolut Vodka bottle was painted onto a facade in New York City. This site was chosen because of its location at the junction of two major streets in SoHo. As the Absolut campaign does not allow advertisements to remain for more than two years, the mural has since been replaced by another ad.

5 Legal Office Mural, Kronish, Lieb, Weiner, Hellman P.C., New York, 1994

This mural, painted in oil and acrylic on canvas, reveals a New York City view through a cut-out clock face. It was commissioned by the law firm for their entrance lobby.

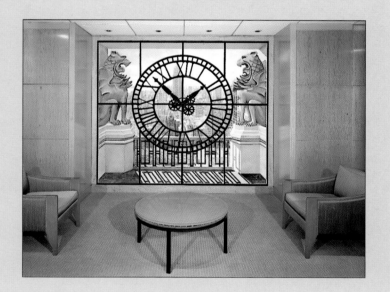

6 *SS Dreamward* (now *SS Dream*), Norwegian Cruise Lines, 1992

One of two murals executed by the artist for the sister ships *Dreamward* and *Windward*. The *Dreamward* mural depicts a reef with undersea life, while the *Windward* painting offers a novel view of the jungle.

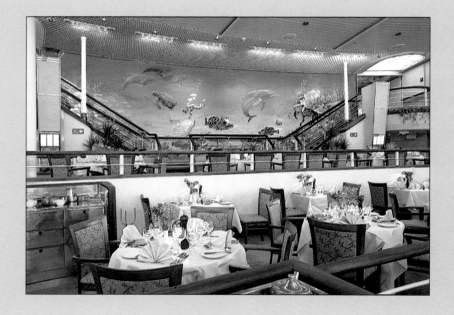

7 Black Hawk Memorial, Rock Island, Illinois, 1992

The artist altered the shape of the roof and filled in four windows to create a sixty-foot-high *trompe l'œil* memorial sculpture of the local Native American hero, Black Hawk.

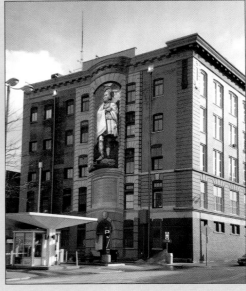

8 Home Savings Office Towers, Pasadena, California, 1990

The two lobbies and their adjacent porticoes were treated with paintings relating to the themes of roses and citrus fruits, including oranges and grapefruits. The City of Pasadena has an annual, world-famous Rose Bowl parade and was at one time an area famous for citrus crops.

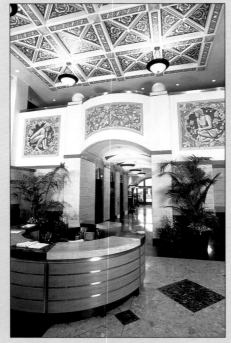

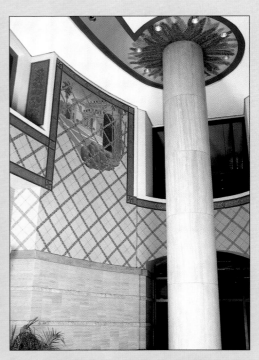

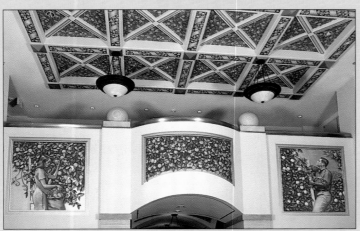

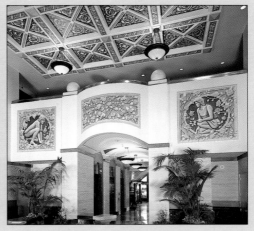

9 White Street Detention Center, New York City, New York (completed 1997)

This complex installation consists of murals and a bridge with two bas-relief sculptures at either end. The imagery is drawn from the historic stories of the Judgment of King Solomon and the Judgment of Chinese General Pao Kung. On an adjacent wall, there are views of the early immigrants who settled the lower East Side of New York.

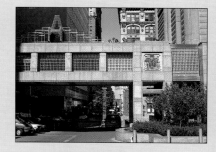
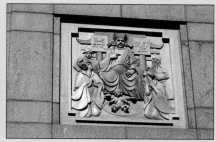
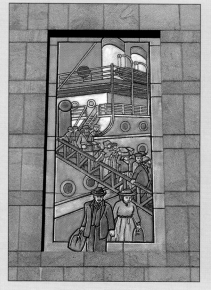
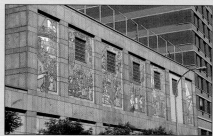
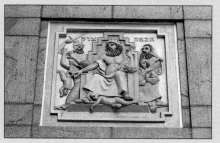

10 The American Craft Museum, New York City, New York, 1988

This temporary installation of shaped canvas above the stairwell of the American Craft Museum was part of an exhibition in 1988 called *Architectural Art: Affirming the Design Relationship.*

11 The Rincon Center, San Francisco, California, 1988

This painted, bas-relief frieze features portraits of well-known San Francisco personages as well as artisans of the area.

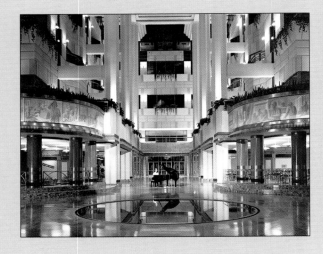

12 Bank One Ballpark, Phoenix, Arizona, 1988

Twenty landscape views were painted onto a curved cement wall in the open-air section of the Bank One Baseball stadium in Phoenix, Arizona. Each "cell" depicts a different scene from Arizona.

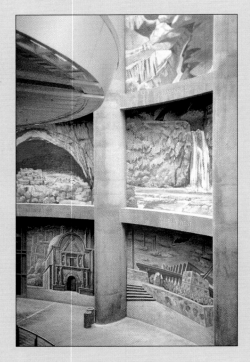

13 The Agronomy Building, Iowa State University, Ames, Iowa, 1986

This pair of paintings, in acrylic and oil on canvas, depicts aspects of agriculture and weather.

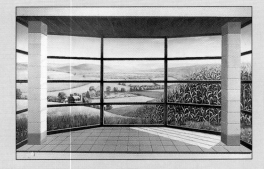

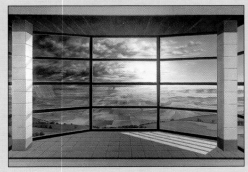

14 Private residence, Madison, Wisconsin, 1986
Inspired by Tiffany stained-glass windows,
this oil and acrylic ceiling mural depicts
the landscape of southern Wisconsin.

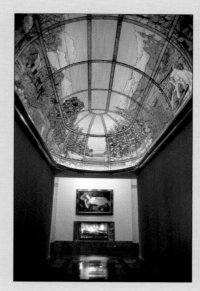
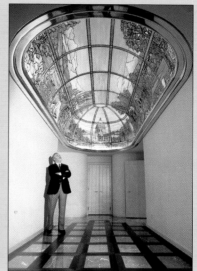

15 The Gair Building, One Main Street,
 Brooklyn, New York, 1985
This building, near the East River in
Brooklyn, New York, features *trompe
l'œil* paintings of marble on the columns
and walls in its lobby.

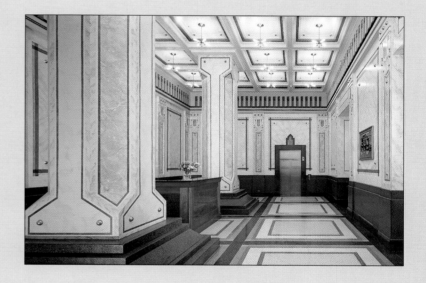

16 Miami Construction Fence,
 Miami, Florida, 1985
This temporary fence was
inspired by Art Deco and the
sculptures of Paul Manship.
It was commissioned by
a local developer to shield
a construction site.

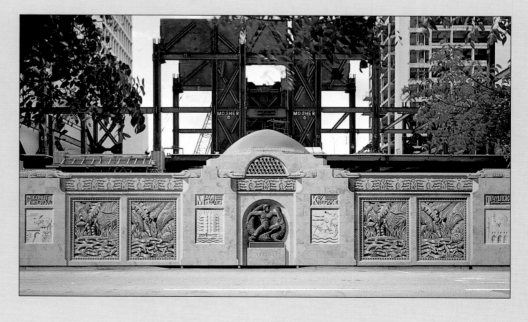

17 Reliable Corporation Warehouse, Eisenhower
 Expressway, Chicago, Illinois, 1985

The architects combined three buildings
into one, onto which the artist painted a
series of views including Burnham's plan
for Chicago, which would have been
centered on the site of the building.

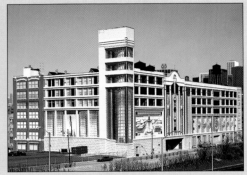

18 Citicorp International Banking Division,
 New York City, New York, 1984

In this installation depicting the world's
financial centers, New York City is
flanked by a view of Geneva, Switzerland,
on the left, and Hong Kong, on the right.

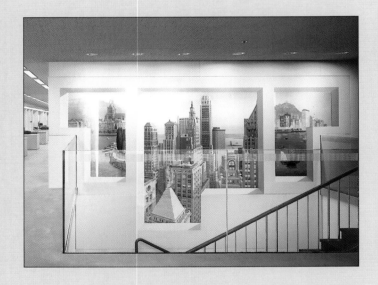

19 Town and Country Mall, Houston, Texas, 1984

Situated in a shopping mall, this mural
is made to resemble stone and is a
stylized interpretation of the architecture of
Houston.

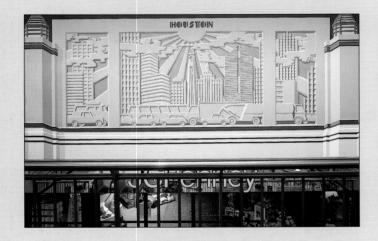

20 The Waterside, Norfolk, Virginia, 1984

This outdoor mural in Keim silicate paint decorates the exterior walls of a waterfront shopping complex. The imagery alludes to the riverfront, located on the opposite side of the building, as it looked seventy years earlier.

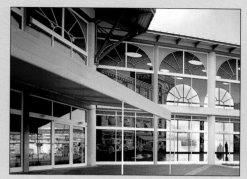
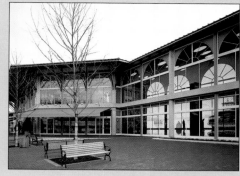

21 Lincoln Building, Washington, D.C., 1984

This building is adjacent to the house where Abraham Lincoln died and opposite Ford's Theater where he was shot. The mural on the building's south side depicts Lincoln as a young man, while the painting on the north side was to show him as president. Only the south side was completed before the Department of the Interior halted the project.

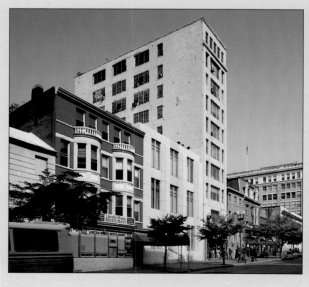
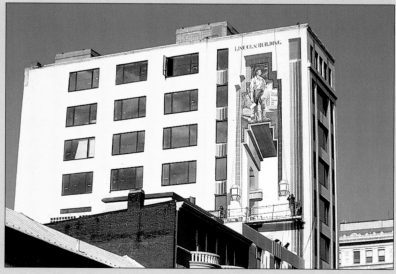

22 Former Republic National Bank,
 Houston, Texas, 1983

These two oil and acrylic paintings on
canvas, installed facing each other from
opposite ends of a hallway, depict the San
Jacinto Monument and the Sam Houston
Monument, both in Houston, Texas.

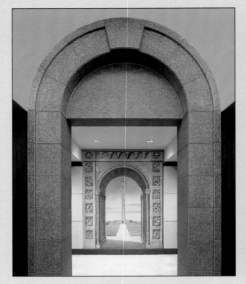
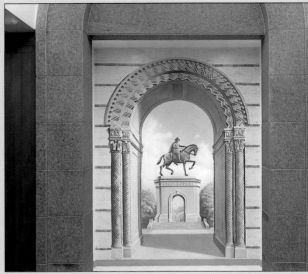

23 The Silk Building Lobby, New York City,
 New York, 1983

This ornate lobby in New York City
depicts workers at various stages of
silk production. The columns and
walls are painted in a faux-marble manner,
which sets off the low relief, gold-leafed
paintings of the silk workers.

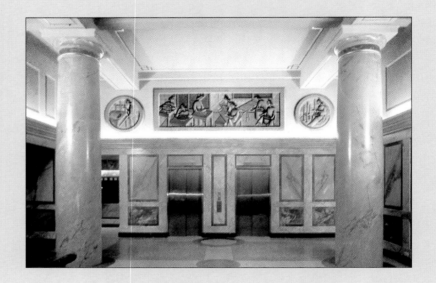

24 Homewood Business District, Homewood,
 Illinois, 1983

A 1930s movie theater was painted
on the back wall of a theater in a small
suburban shopping complex in Homewood,
Illinois. The theater was destroyed in 1990.

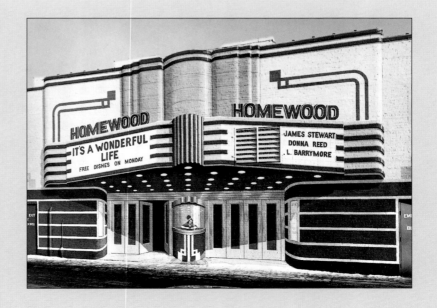

25 **Private apartment, Chicago, Illinois, 1982**
This private mural, painted on screens in oil and acrylic, makes reference to Tiffany-style glass and depicts a real view of Chicago which exists beyond the windows.

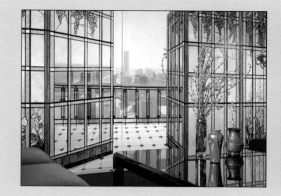 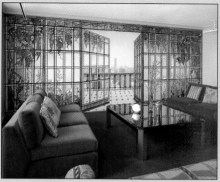

26 **426–430 West Broadway, New York City, New York, 1982**
The artist collaborated with architect Edward Mills and building owner Peter Nelson on this mid-rise in SoHo, which is a typical late nineteenth-century warehouse that was rehabilitated as an apartment building with stores on the ground floor.

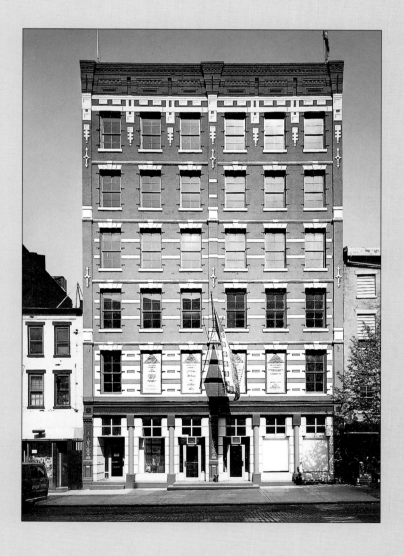

27 Philip Morris Dining Room, New York City,
 New York, 1981

Painted in oil and acrylic on canvas,
this mural, in the sub-basement of Philip
Morris, offers employee diners a "view" of
New York as seen from thirty floors above.
The entrance to the dining room is painted
in an Art Deco style and features Philip
Morris's "Johnnys" at either side. Another
mural, across from the elevator bank,
provides a rooftop view.

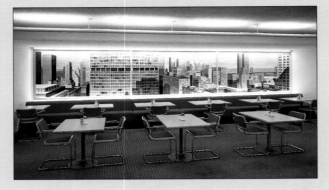

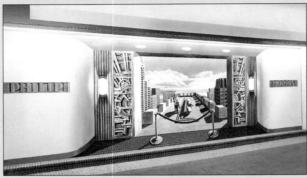

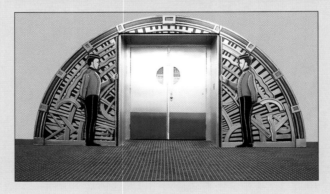

28 The MIT Pantheon of Honor, Massachusetts
 Institute of Technology, Boston,
 Massachusetts, 1981

This temporary museum installation
appears to be a three-dimensional space
with Pantheon-style architecture. At one
end, the names of important, past MIT
scholars are painted to resemble chiseled
stone. As the viewer progresses to the
other end of the gallery, the lines become
lighter and softer, with the names of
younger and more recent honorees.

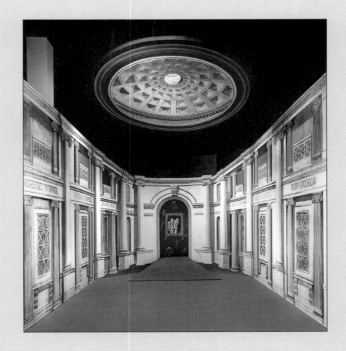

29 The Hamden Plaza, Hamden, Connecticut, 1981

A collaboration with artist David MacCauley, this project combined real sections of ruin with a painted depiction of the apple orchard that once graced the land on which this strip mall was built.

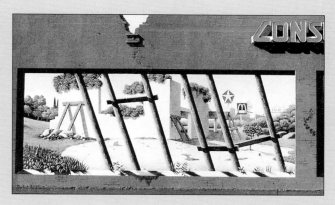

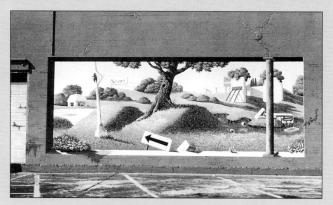

30 The DeWitt Wallace Periodical Room at the New York Public Library, 42nd Street, New York City, New York, 1981

The Readers' Digest Corporation commissioned fourteen canvases depicting New York publishing houses. Since the original commission had gone to artist Edwin Lanning, who died before his designs were executed, Haas was able to propose new ideas for the murals.

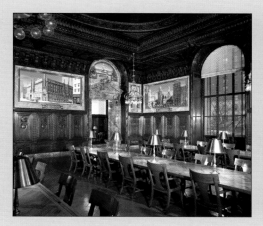

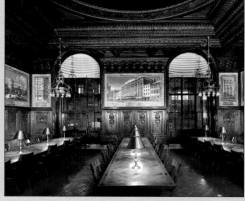

31 Alwyn Court, 180 West 58th Street,
 New York City, New York, 1981

Working closely with the building's
architects, Beyer, Blinder, Belle of New
York City, the artist painted a replica
of the elaborate exterior terracotta walls
of the original Harde Short Building.

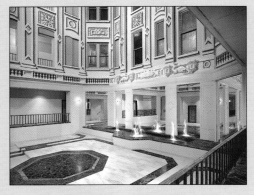

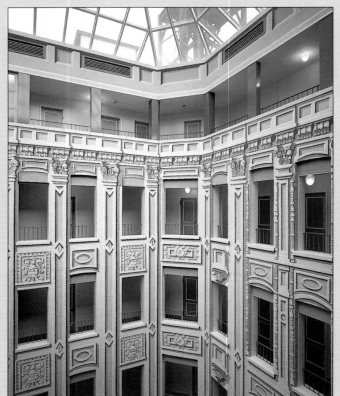

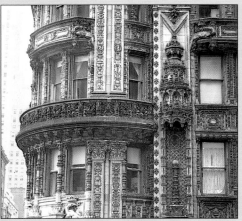

32 Private office, Chicago, Illinois, 1980

This oil and acrylic painting on canvas
is installed in the boardroom of a private
corporation and depicts a view of the
Chicago skyline.

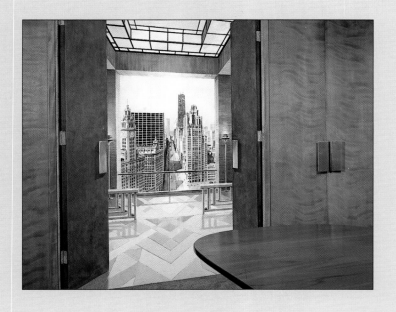

33 Chestnut Place Lobby, State and
 Chestnut Streets, Chicago, Illinois, 1980

The lobby is transformed by a
miniature version of San Miniato
in Florence, Italy, and a faux,
inlaid wooden floor.

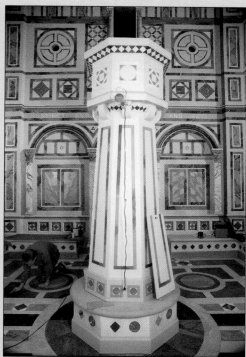
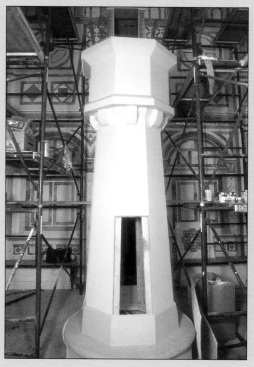
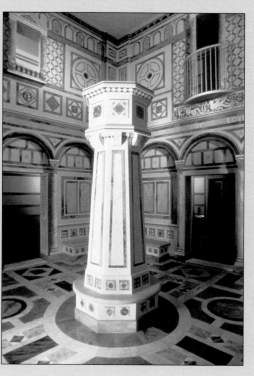

34 Dyer Avenue Murals, 42nd Street
 Redevelopment Corporation, New York City,
 New York, 1979

To launch the 42nd Street Redevelopment
Campaign, the artist was commissioned
to design a suite of outdoor murals to
rejuvenate the then-dilapidated area.
The two murals flank the entrance and
exits of the Lincoln Tunnel.

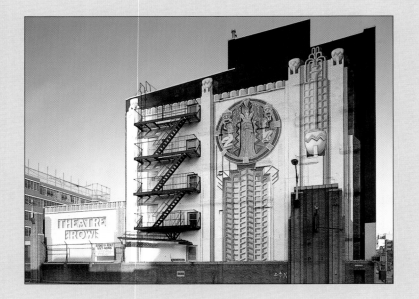

35 New York University Center for Continuing
 Education, New York City, New York, 1979

This commission consisted of eight oil
and acrylic paintings installed at the ends
of long hallways in the New York University
Center for Continuing Education. The
artist worked with the Center's architects,
Edward Mills and Bartholomew
Voorsanger, to design murals depicting
views of the surrounding area as reflected
by the floor plan of the building.

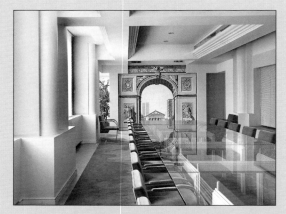

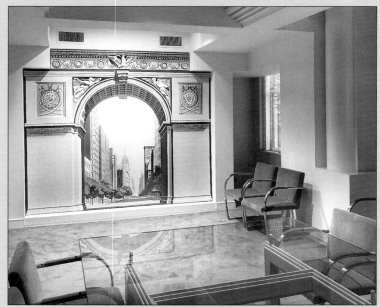

94

36 The Springer Building on the Strand,
 Galveston, Texas, 1976

Painted in oil on two two-storey
buildings, this *trompe l'œil* facade
unifies this contemporary building
with its turn-of-the-century
neighbor.

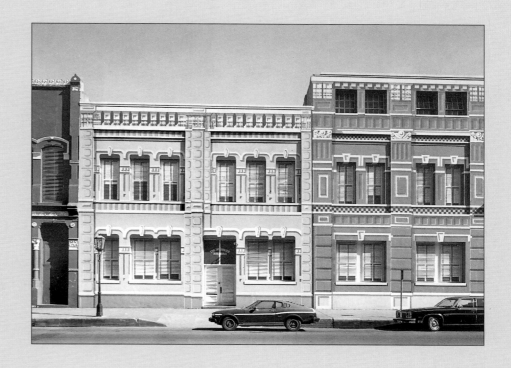

Photo credits

All photographs courtesy of Richard Haas
All photographs © Richard Haas with the exception of the following:

© Peter Aaron / Esto: p. 80 (no. 1)
AKG Berlin: pp. 7 (bottom), 11 (bottom), 12 (top), 16 (left)
© Grey Crawford Photography, CA: p. 82 (no. 2)
© Bevan Davies: p. 15 (left)
© Herb Engelsberg: p. 90 (no. 28)
© Jim England Photography, Los Angeles, CA: p. 66
© David Hewitt: half title and p. 43
© Bill Horsman Photography: back cover and pp. 70–1
© Douglas Kahn: pp. 44 (top), 72
© S.D. King, p. 95 (no. 36)
© Peter Mauss / Esto: front cover and pp. 8 (right), 9, 23, 25, 34, 35 (right, far right),
 36 (bottom right), 37, 41, 47, 49, 52 (left), 57, 58 (bottom), 59, 61, 81 (no. 4 right; no. 6),
 83 (no. 10), 86 (no. 19), 87 (no. 20), 88 (no. 22, 24), 89 (no. 25 & 26 left), 90 (no. 27),
 92 (no. 31 left & top right), 94 (no. 34–5)
Prestel Archive: pp. 11 (top) & 17 (left)
© Sid Richardson Collection of Western Art: p. 33
© Alan Schindler: p. 85 (no. 15)
© W.D. Smith, Inc. Commercial Photography, Fort Worth, TX: p. 32 (top center)
© Srenco Photography, Olivette, MI: pp. 26 (fourth row), 27
© Michael Tropea: p. 86 (no. 17 right)
© Whittaker Photography, CA: p. 84 (no. 11)
© Ed. A. Wilson, Inc.: p. 44 (center)